Cutting-Edge
Patterns and Textures

ROCKPORT

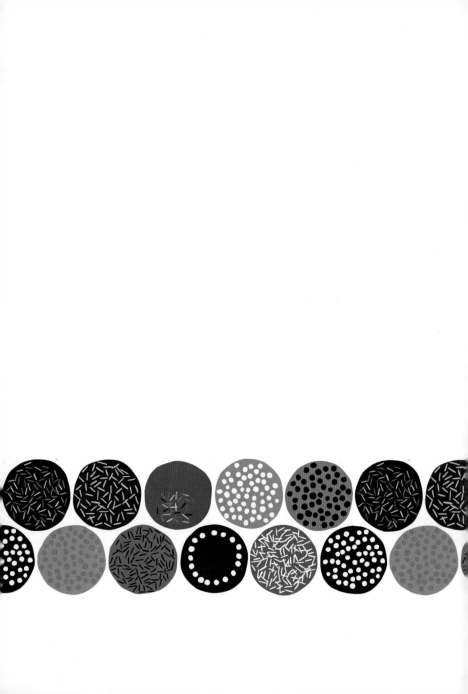

BEVERLY MASSACHUSETTS

Cutting-Edge
Patterns and Textures

ROCKPORT PUBLISHERS

Copyright © 2007 by maomao publications
First published in 2008 in the United States of America by
Rockport Publishers, a member of
Quayside Publishing Group
100 Cummings Center
Suite 406-L
Beverly, MA 01915-6101
Telephone: (978) 282-9590
Fax: (978) 283-2742
www.rockpub.com

ISBN-13: 978-1-59253-428-9
ISBN-10: 1-59253-428-7

Publisher director: **Paco Asensio**
Editorial coordinator: **Anja Llorella Oriol**
Publisher: **Estel Vilaseca**
Texts: **Cristian Campos**
Art director: **Emma Termes Parera**
Graphic design and layout: **Gemma Gabarron Vicente**
English translation: **Antonio Moreno**

Editorial project:
maomao publications
C/ Tallers 22 bis, 3º 1ª
08001 Barcelona. Spain
Tel.: +34 93 481 57 22
Fax: +34 93 317 42 08
www.maomaopublications.com

Printed in China

CONTENTS

INTRODUCTION

It has been claimed that the incessant repetition of the same few words is one of the top ten reasons that the children's television series *Teletubbies* connects so well with children under the age of four. But once one turns four, the *Teletubbies* lose their naive charm and are replaced by other kinds of repetition, including graphic patterns, which can be designed for wallpaper, fabric, tile, computer desktop backgrounds, wrapping paper . . . or simply for fun, without any practical use or particular format in mind.

Practically all designers have succumbed, at one point or another, to the temptation of designing a graphic pattern. Some have opted for simplicity, others for the obsessively baroque; some for monochromatic patterns and others for colorful explosions. But the majority have devoted hours and hours of their time to taking different elements of a pattern and making a brainteaser of them, as it is easy to imagine Dutch artist M.C. Escher doing in the 1950s. Escher, by the way, said that his work was much closer to the world of mathematics than to the world of art.

Perhaps one of the ten reasons we are irresistibly attracted to patterns is their entertainment potential: who hasn't run their hands over the wallpaper of one of the rooms in

their home hoping to find (to no avail, of course) a discordant element in the pattern? And who hasn't sought out its limits—that point where the motif ends and connects all over again with its beginning?

That patterns are playful and have more to do with mathematics than design is something that could easily be said by any of the eighty-three designers, artists, and graphic design studios featured in this book. The over 250 patterns included here form a detailed collection of the latest trends in the field of graphic design patterns. New styles and new techniques form an unprecedented visual feast for the eyes, which will interest not only graphic designers, but also readers who are fascinated by the almost hypnotic beauty of patterns that repeat themselves into infinity. After all, what is a graphic pattern but an attempt to imitate, to our best capability, the fractals of nature? A good deal of the graphic patterns in this book have been published in other formats, but many are printed here for the very first time.

Dots Obsession

Yayoi Kusama

www.yayoi-kusama.jp

Untitled

Hello Hello

www.hellohello.name

1957

Emil Kozak

www.emilkozak.com

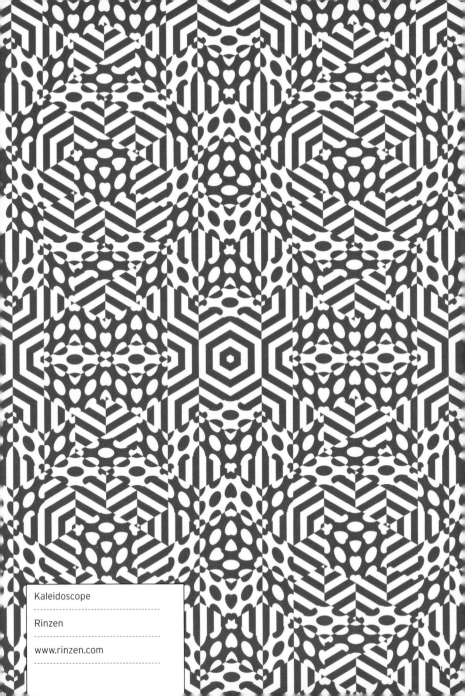

Kaleidoscope

Rinzen

www.rinzen.com

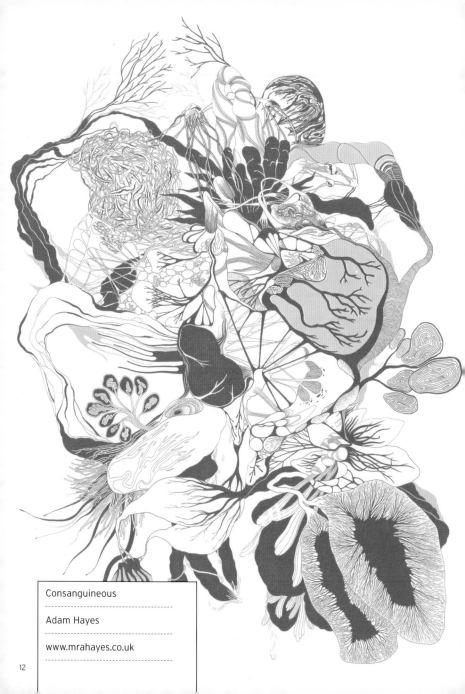

Consanguineous

Adam Hayes

www.mrahayes.co.uk

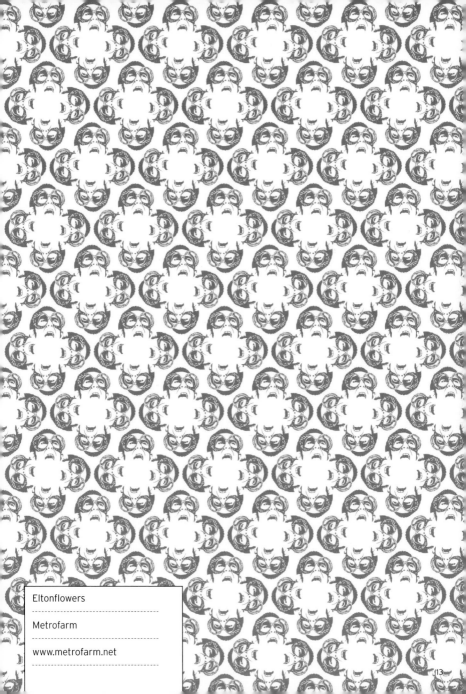

Eltonflowers

Metrofarm

www.metrofarm.net

Piggy

Henrik Vibskov

www.henrikvibskov.com

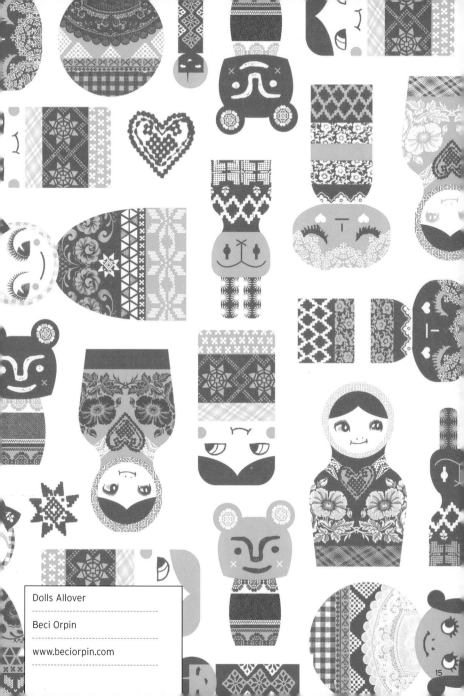

Dolls Allover

Beci Orpin

www.beciorpin.com

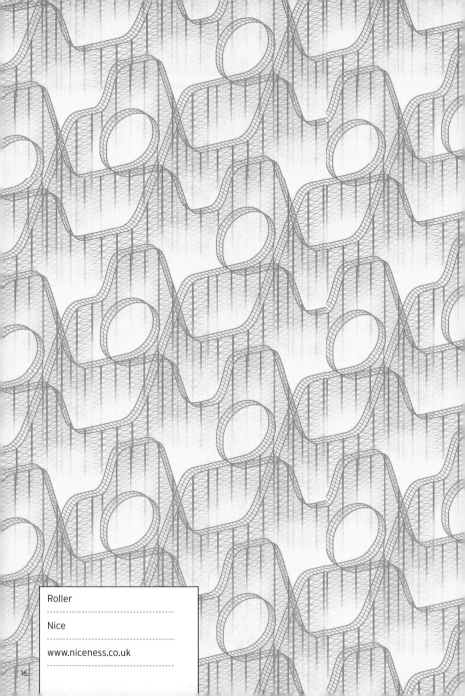

Roller

Nice

www.niceness.co.uk

Polska

Metrofarm

www.metrofarm.net

Brenin

Galina

mari-art-i.livejournal.com

Deco Floral

Simone Jessup

www.simonejessup.com

Flora

Estudio Mopa

www.estudiomopa.com

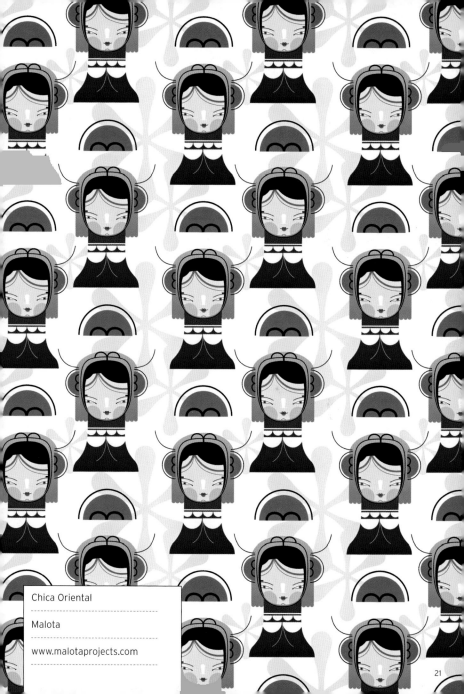

Chica Oriental

Malota

www.malotaprojects.com

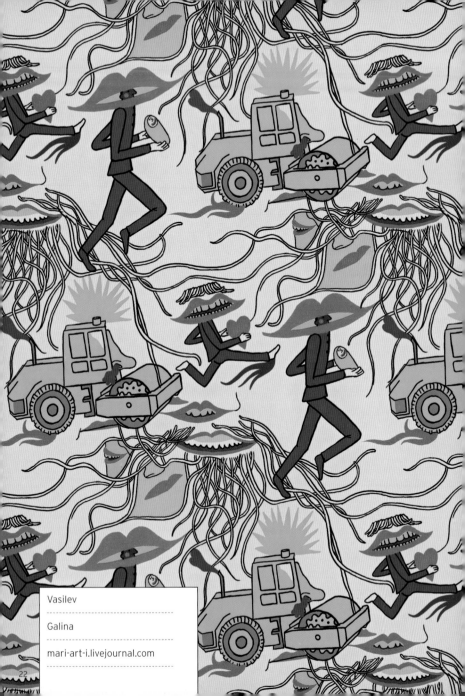

Vasilev

Galina

mari-art-i.livejournal.com

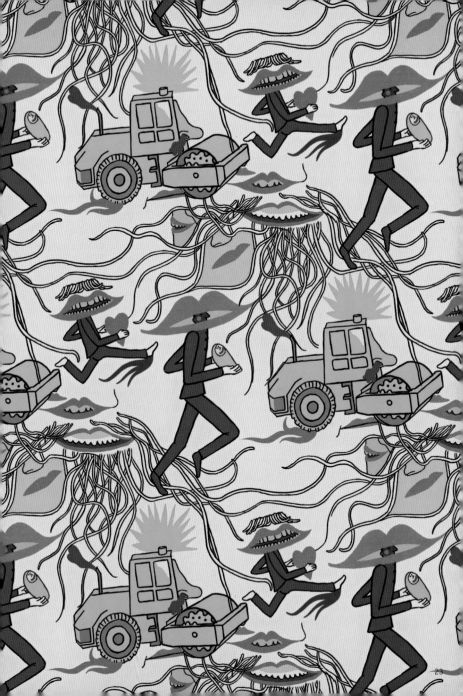

Hanabi

Mina Wu

www.wretch.cc/blog/minawu

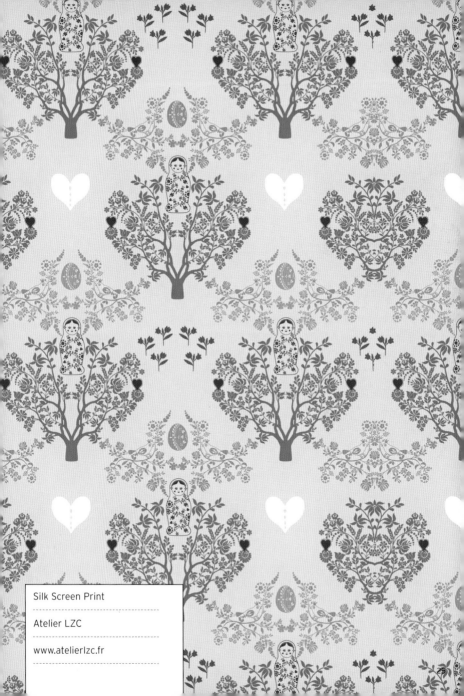

Silk Screen Print

Atelier LZC

www.atelierlzc.fr

Delicioso

Catriel Martínez

www.catnez.com.ar

Metro Lolly Delux

Esther Hong

www.jinizm.com

Mosquitos

Catalina Estrada

www.catalinaestrada.com

Day Pink

Lotta Kühlhorn

www.lottakuhlhorn.se

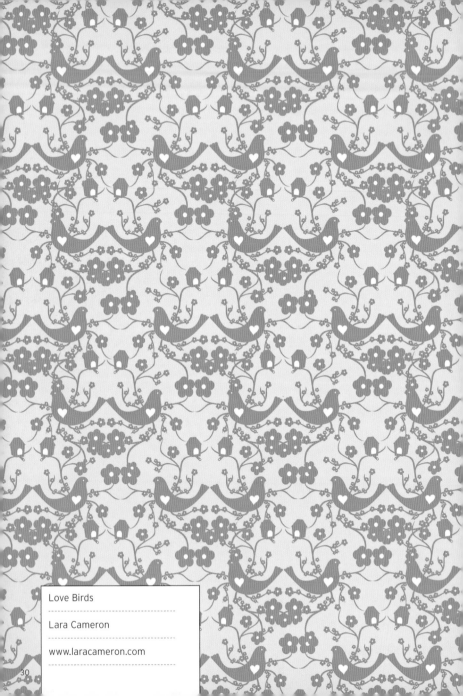

Love Birds

Lara Cameron

www.laracameron.com

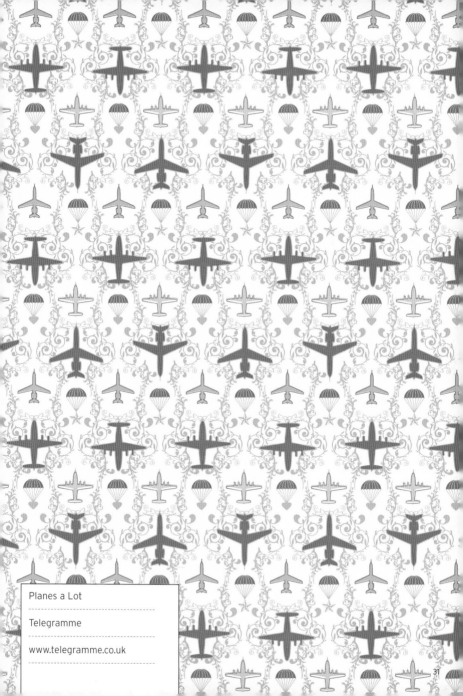

Planes a Lot

Telegramme

www.telegramme.co.uk

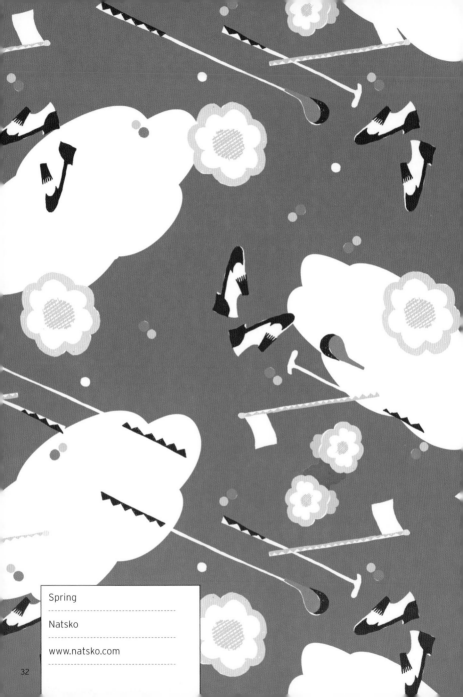

Spring

Natsko

www.natsko.com

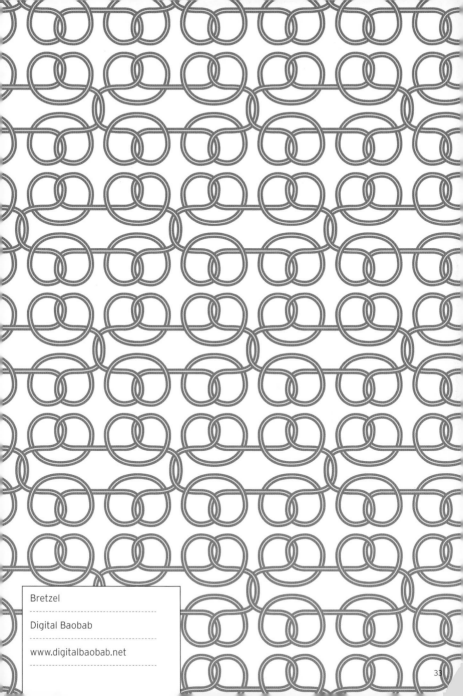

Bretzel

Digital Baobab

www.digitalbaobab.net

33

Scheherazade

Maja Sten

www.majasten.se

Woodgrain Words and Whorls

Lara Cameron

www.laracameron.com

Angles

--

Erica Wakerly

--

www.printpattern.com

--

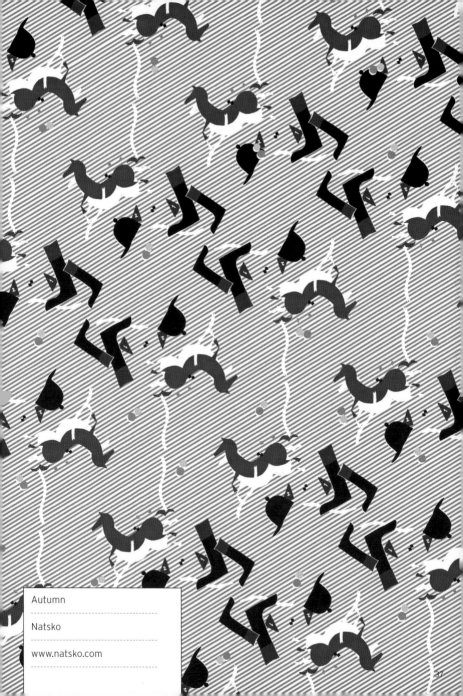

Autumn

Natsko

www.natsko.com

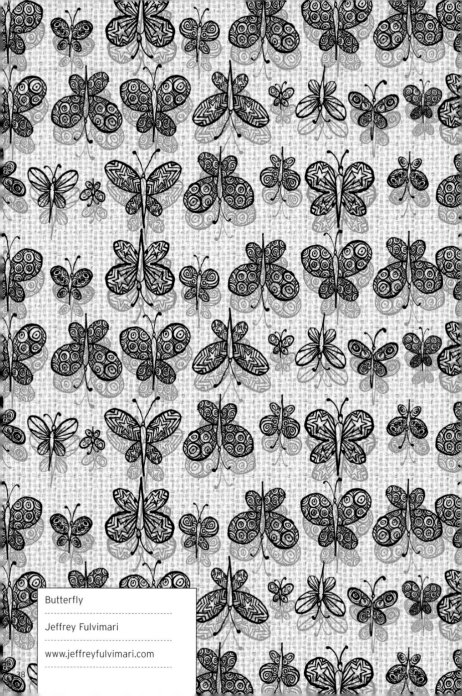

Butterfly

Jeffrey Fulvimari

www.jeffreyfulvimari.com

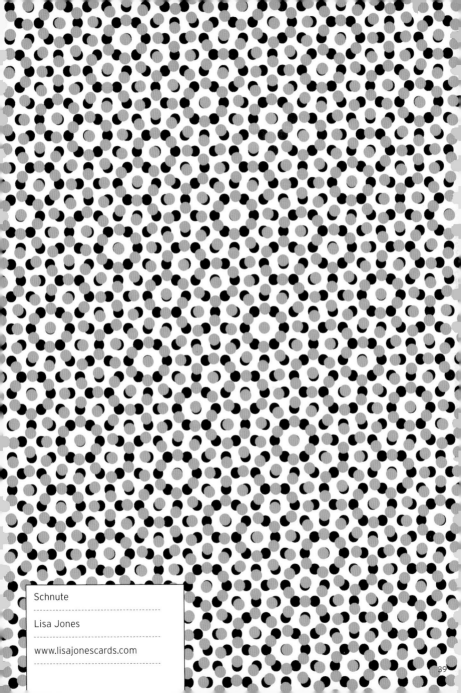

Schnute

Lisa Jones

www.lisajonescards.com

Frogprint

Henrik Vibskov

www.henrikvibskov.com

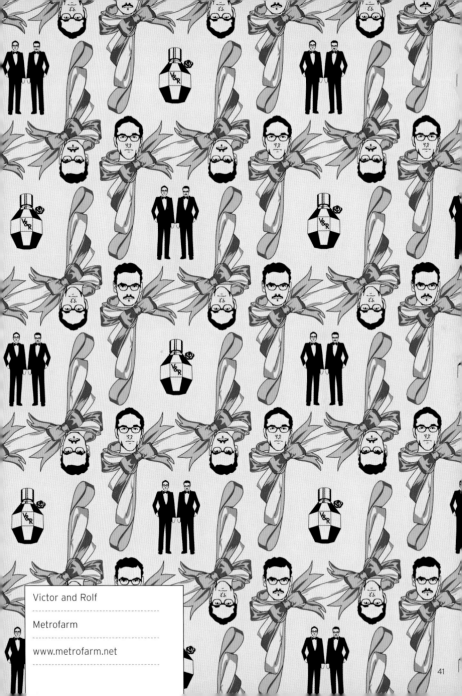

Victor and Rolf

Metrofarm

www.metrofarm.net

Beet Root Pink

Lotta Kühlhorn

www.lottakuhlhorn.se

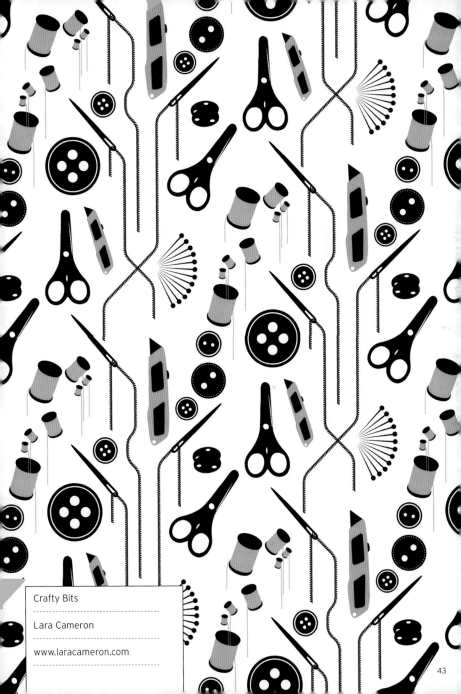

Crafty Bits

Lara Cameron

www.laracameron.com

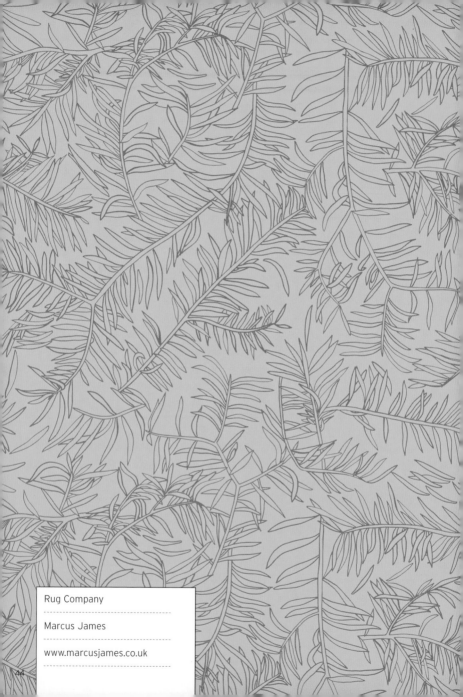

Rug Company

Marcus James

www.marcusjames.co.uk

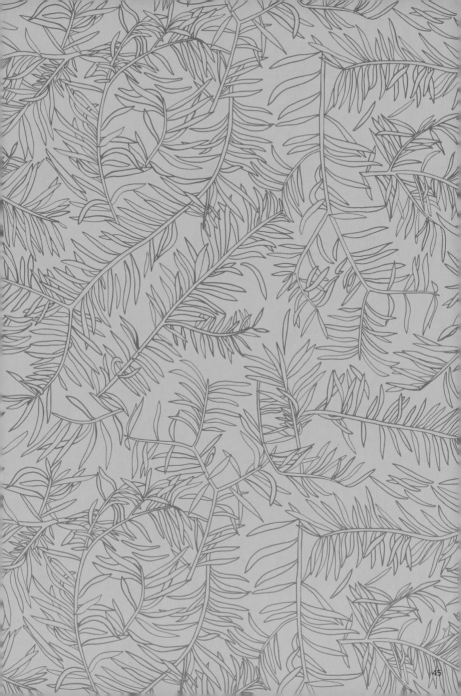

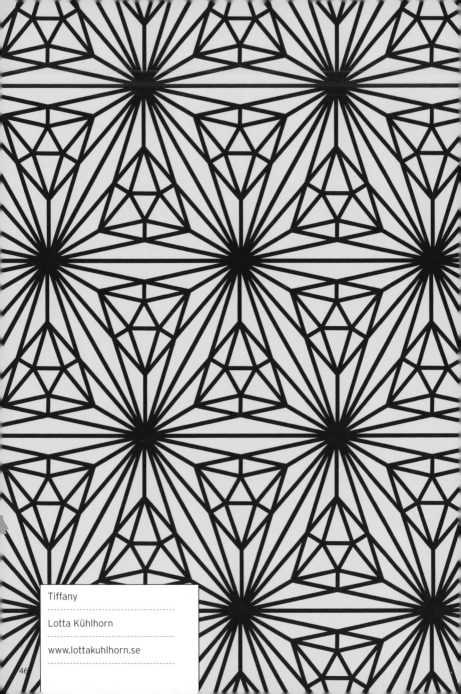

Tiffany

Lotta Kühlhorn

www.lottakuhlhorn.se

Cayen

Jessica Romberg

www.stockholmillustration.com

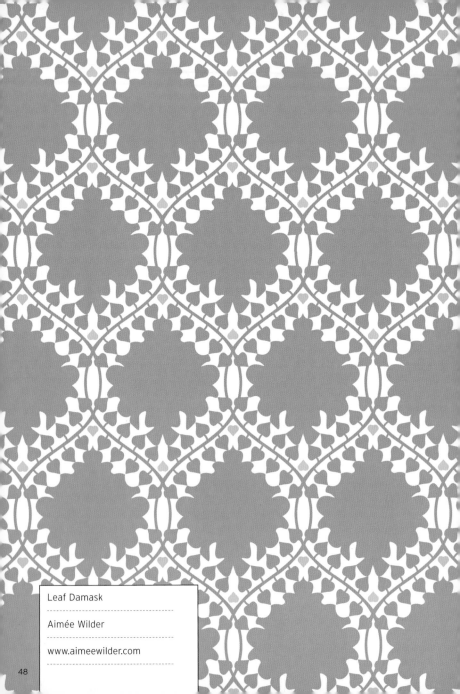

Leaf Damask

Aimée Wilder

www.aimeewilder.com

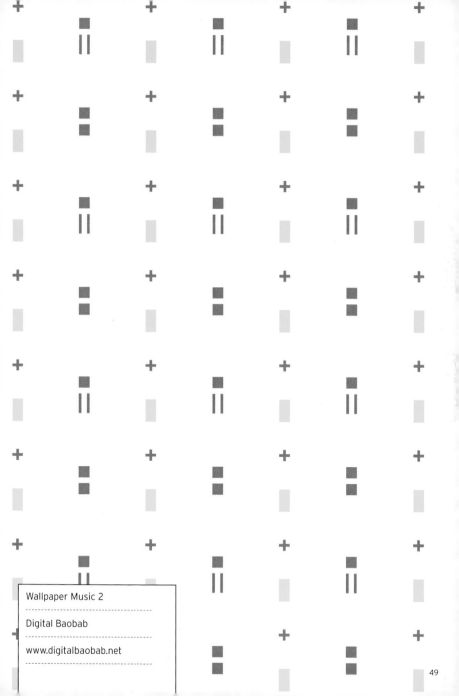

Wallpaper Music 2

Digital Baobab

www.digitalbaobab.net

49

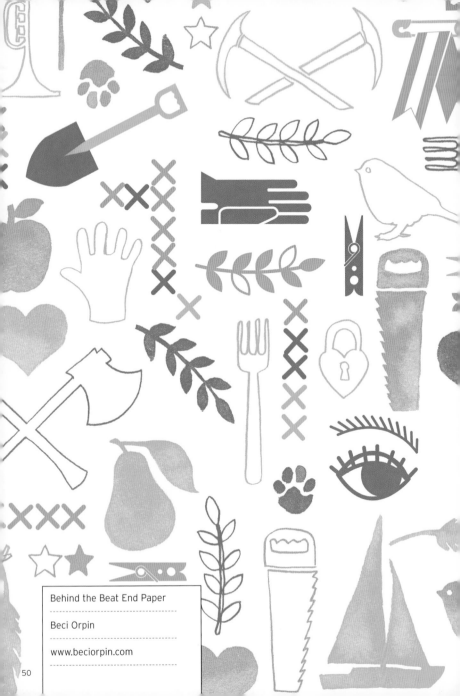

Tennis

Digital Baobab

www.digitalbaobab.net

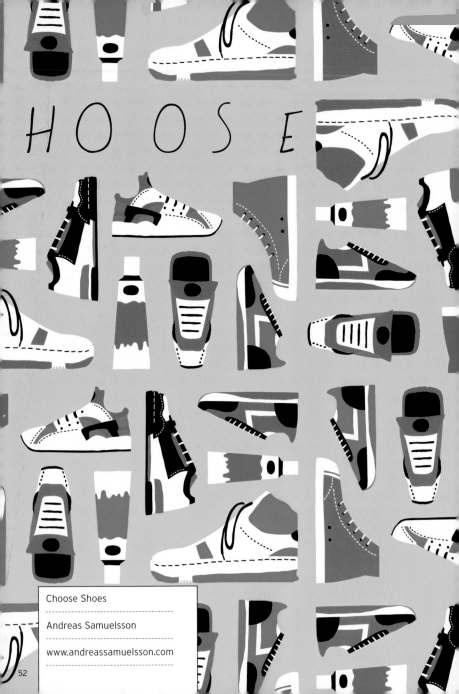

HO OS E

Choose Shoes

Andreas Samuelsson

www.andreassamuelsson.com

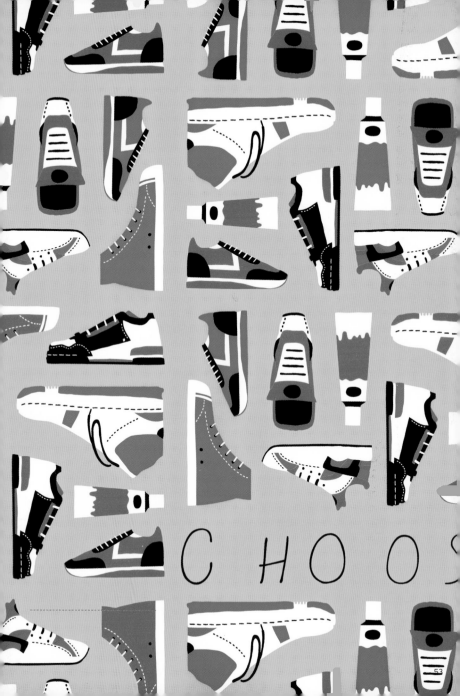

C HO O S

Tulip

Anne Kyyrö Quinn

www.annekyyroquinn.com

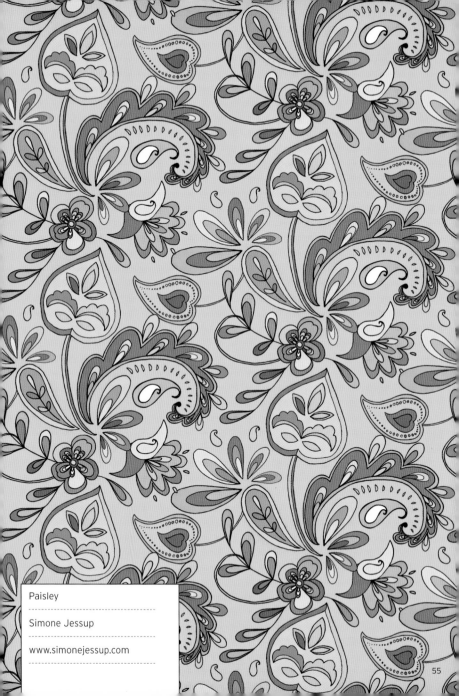

Paisley

Simone Jessup

www.simonejessup.com

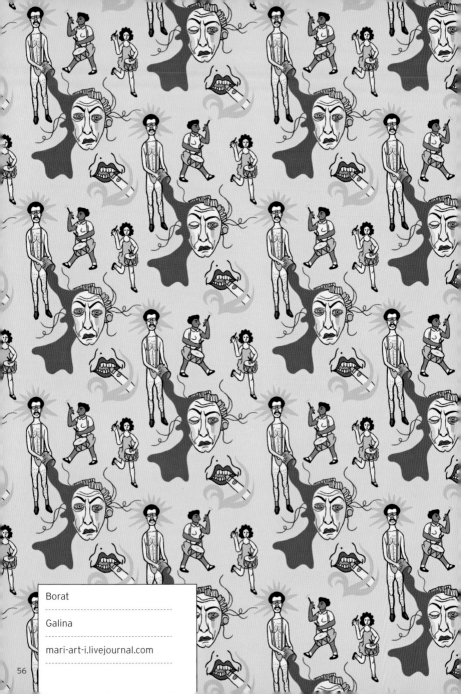

Borat

Galina

mari-art-i.livejournal.com

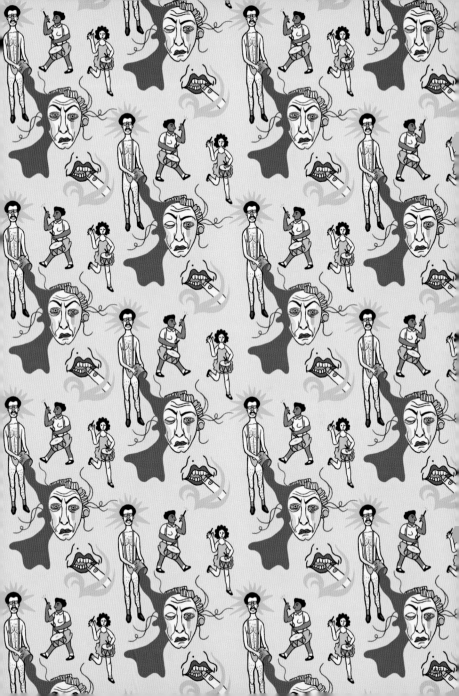

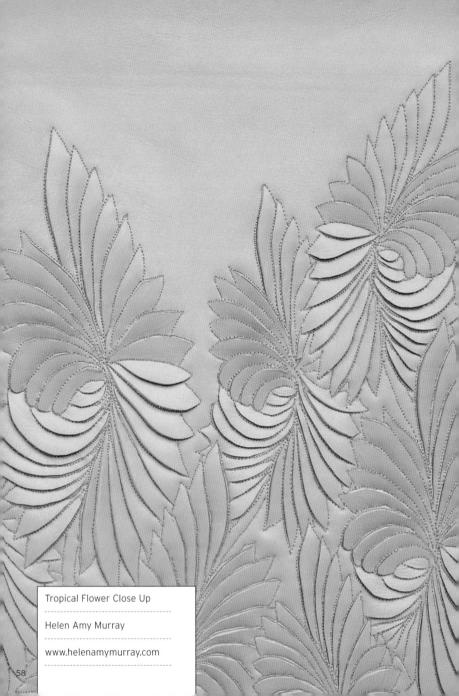

Tropical Flower Close Up

Helen Amy Murray

www.helenamymurray.com

River Stones

Lara Cameron

www.laracameron.com

Chainlink Cluster

Aimée Wilder

www.aimeewilder.com

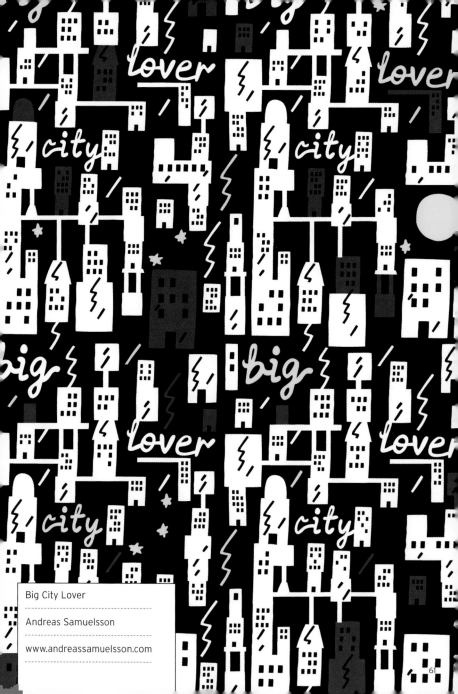

Big City Lover

Andreas Samuelsson

www.andreassamuelsson.com

Flocked wallpaper

Alex Lin

www.alexlin.org

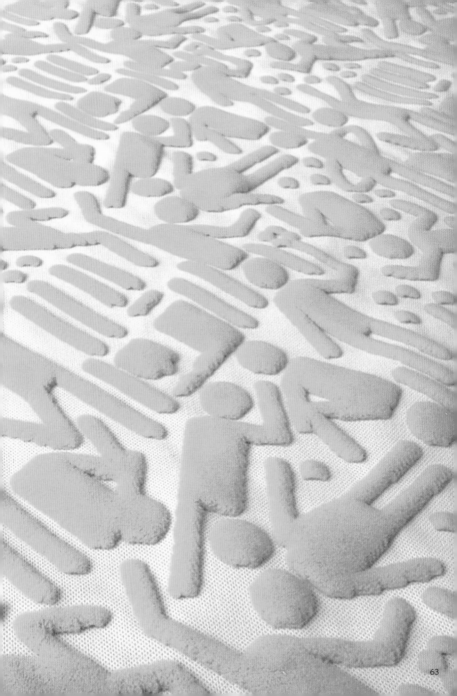

Spot

Helen Amy Murray

www.helenamymurray.com

Koldbrand Pen

Koldbrand

www.koldbrand.com

Palm

Carly Margolis

www.cavernhome.com

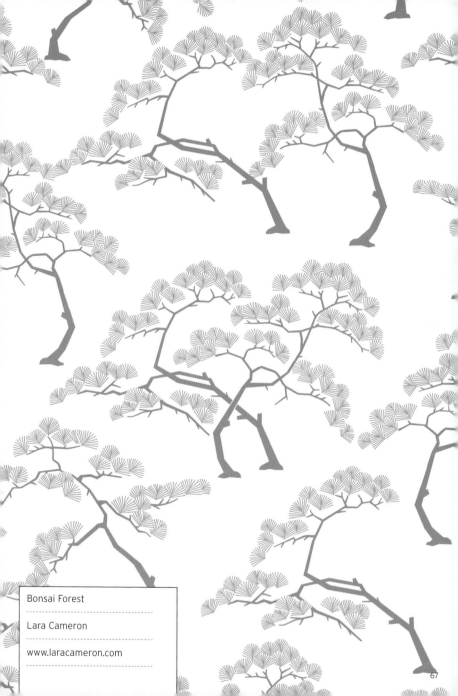

Bonsai Forest

Lara Cameron

www.laracameron.com

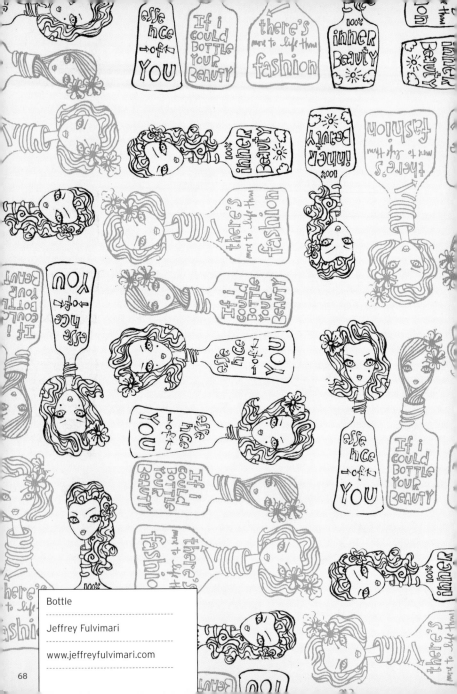

Bottle

Jeffrey Fulvimari

www.jeffreyfulvimari.com

Burn Out

Eugène van Veldhover

www.dutchtextiledesign.com

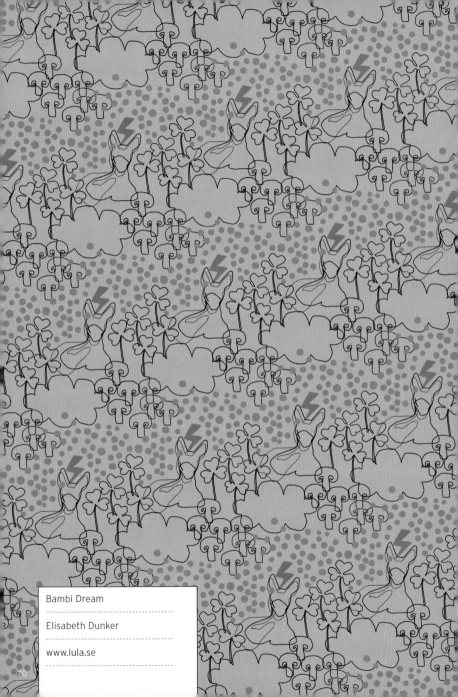

Bambi Dream

Elisabeth Dunker

www.lula.se

Rose

Helen Amy Murray

www.helenamymurray.com

Kelp

Esther Hong

www.jinizm.com

Wallpaper

Atelier LZC

www.atelierlzc.fr

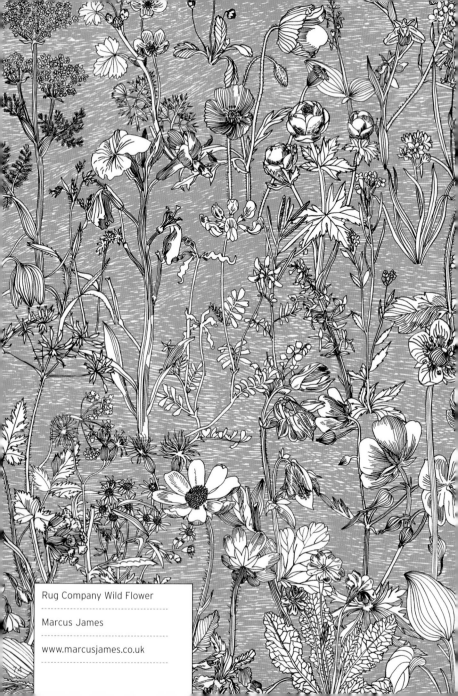

Rug Company Wild Flower

Marcus James

www.marcusjames.co.uk

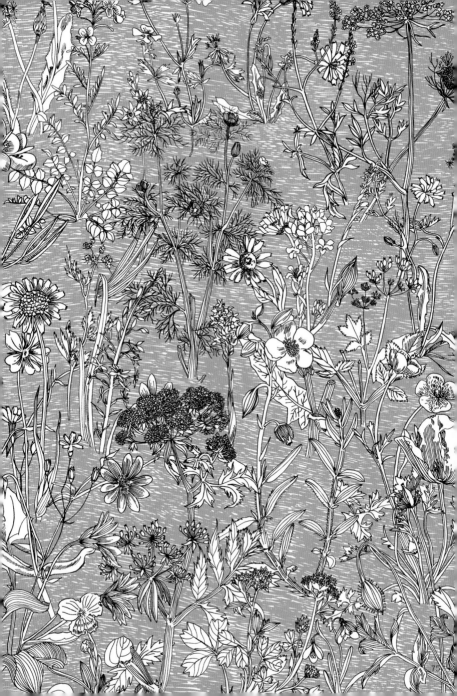

Explorer

Me Company

www.mecompany.com

Rosette

Anne Kyyrö Quinn

www.annekyyroquinn.com

Relief Print Plus Coating

Eugène van Veldhover

www.dutchtextiledesign.com

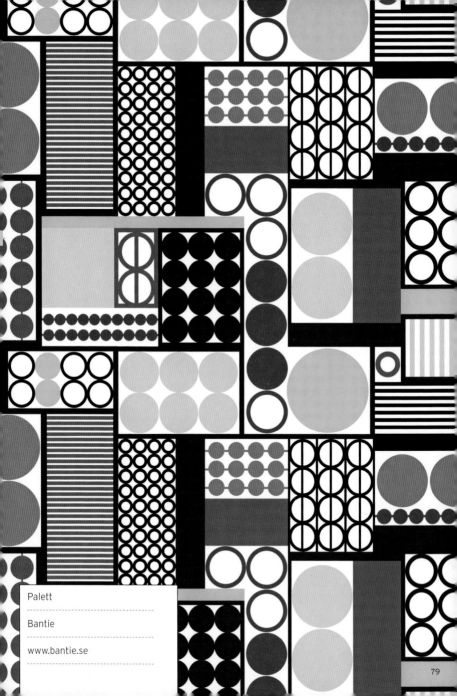

Palett

Bantie

www.bantie.se

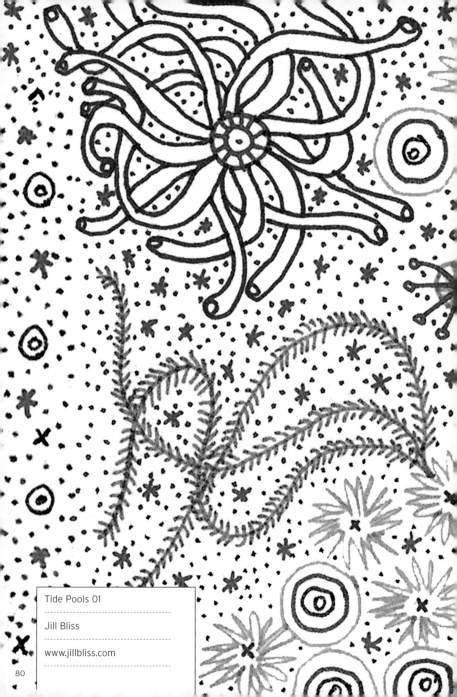

Tide Pools 01

Jill Bliss

www.jillbliss.com

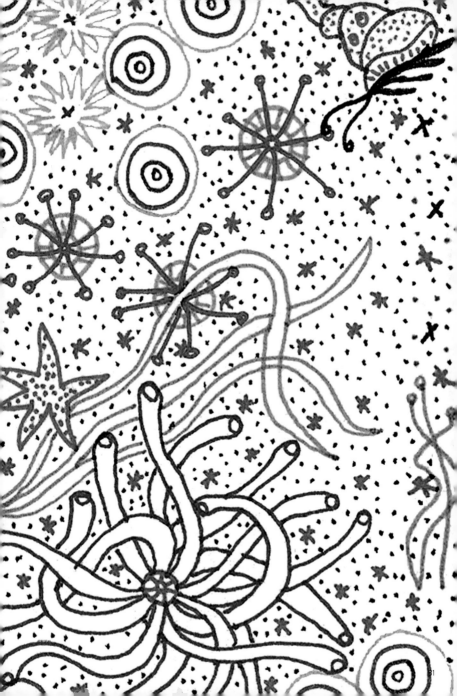

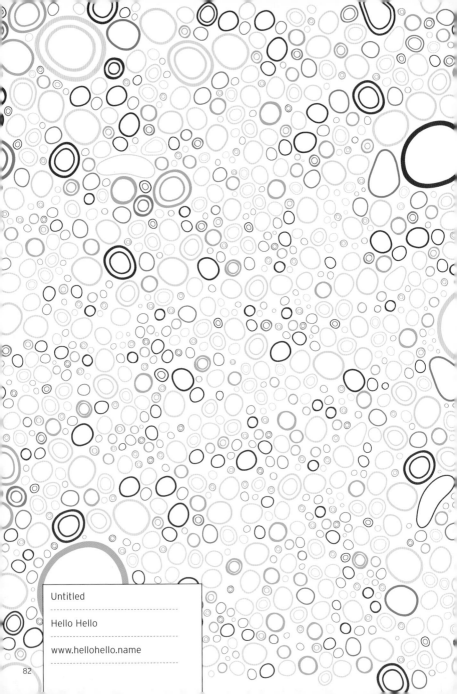

Untitled

Hello Hello

www.hellohello.name

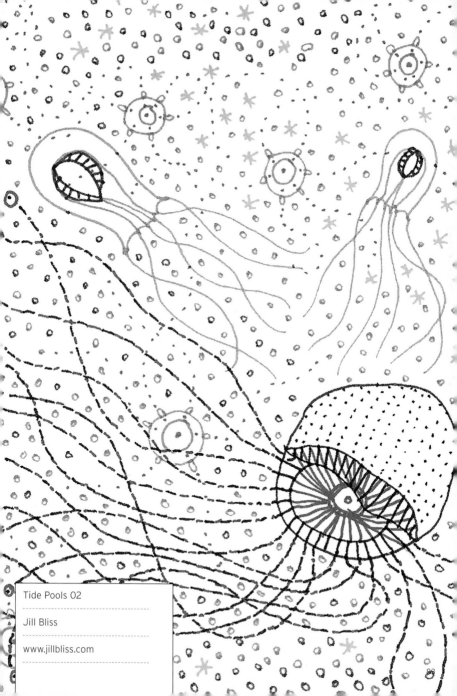

Tide Pools 02

Jill Bliss

www.jillbliss.com

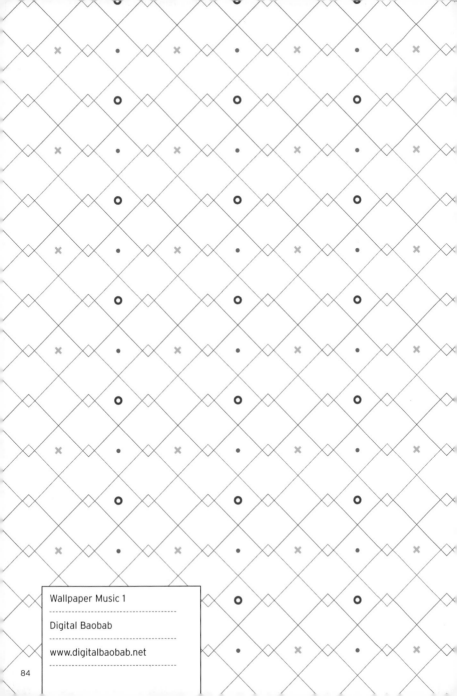

Wallpaper Music 1

Digital Baobab

www.digitalbaobab.net

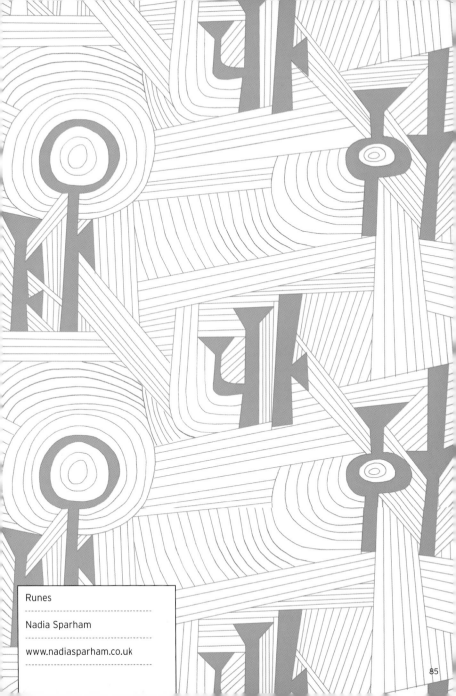

Runes

Nadia Sparham

www.nadiasparham.co.uk

Flower

Mocchi Mocchi

www.mocchimocchi.com

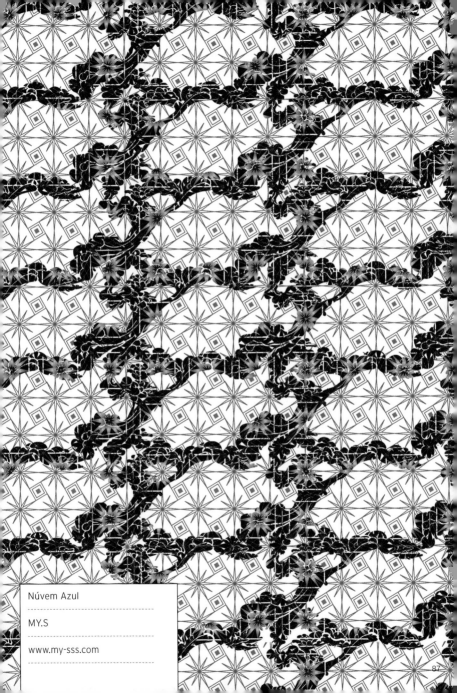

Núvem Azul

MY.S

www.my-sss.com

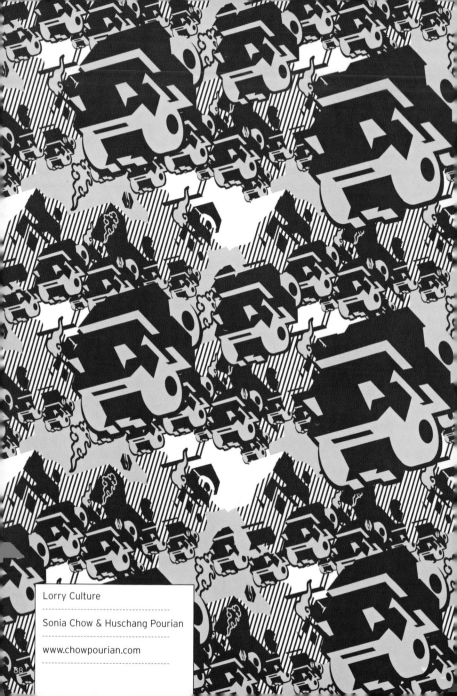

Lorry Culture

Sonia Chow & Huschang Pourian

www.chowpourian.com

The Passing of Winter

Yayoi Kusama

www.yayoi-kusama.jp

Zimmermann Owls

Rinzen

www.rinzen.com

Crop Circles

Aimée Wilder

www.aimeewilder.com

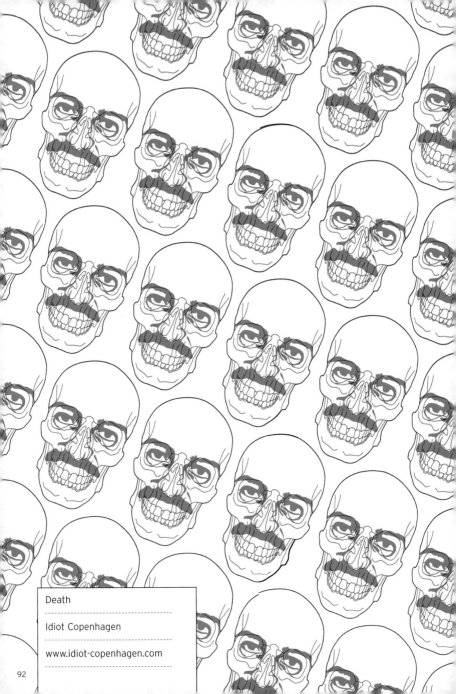

Death

Idiot Copenhagen

www.idiot-copenhagen.com

Travel

Idiot Copenhagen

www.idiot-copenhagen.com

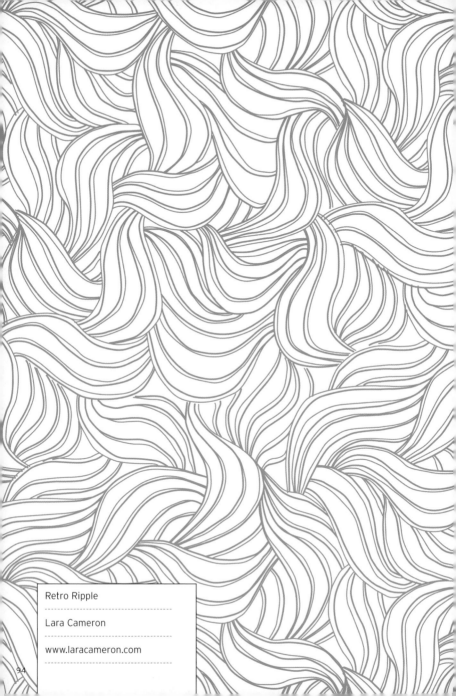

Retro Ripple

Lara Cameron

www.laracameron.com

94

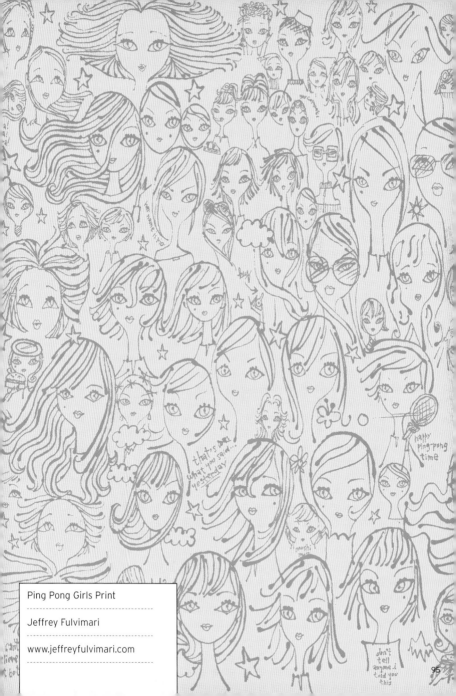

Ping Pong Girls Print

Jeffrey Fulvimari

www.jeffreyfulvimari.com

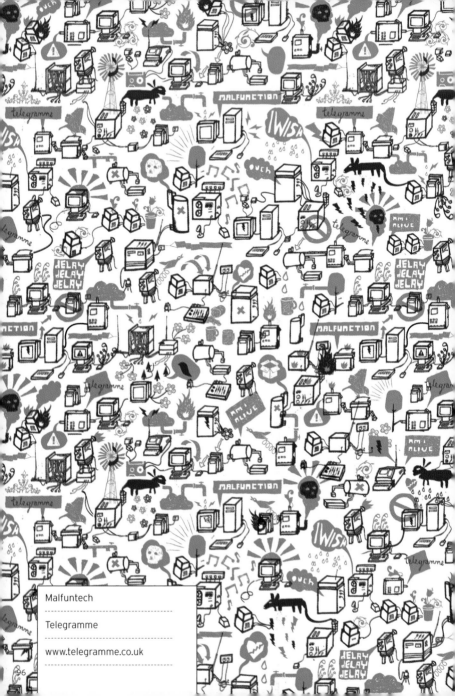

Malfuntech

Telegramme

www.telegramme.co.uk

Mod Damask

Aimée Wilder

www.aimeewilder.com

Zimmermann Cloud

Rinzen

www.rinzen.com

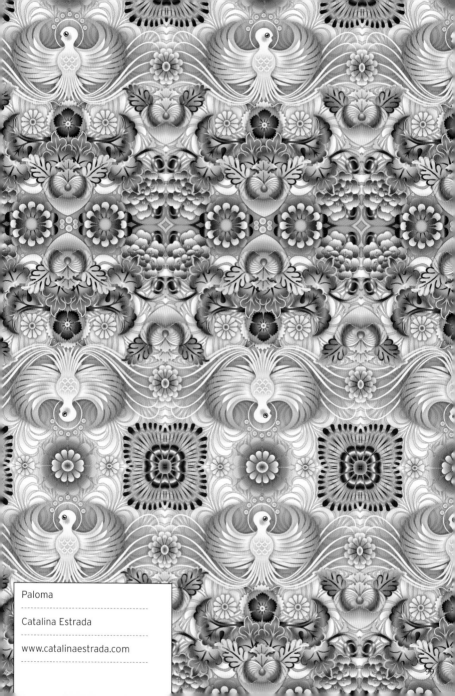

Paloma

Catalina Estrada

www.catalinaestrada.com

Racing Cards

Hello Monday

www.hellomonday.net

I'm Here But Nothing

Yayoi Kusama

www.yayoi-kusama.jp

Untitled

Chisato Shinya

www.kin-pro.com

Blue Bird

Eleanor Grosch

www.pushmepullyoudesign.com

Face

Galina

mari-art-i.livejournal.com

Blue Tears

Brit Hammer

www.brithammer.com

Ben

Extratapete

www.extratapete.de

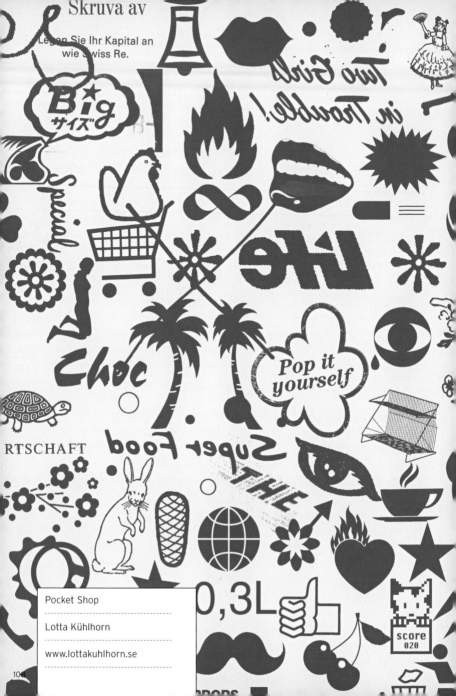

Pocket Shop

Lotta Kühlhorn

www.lottakuhlhorn.se

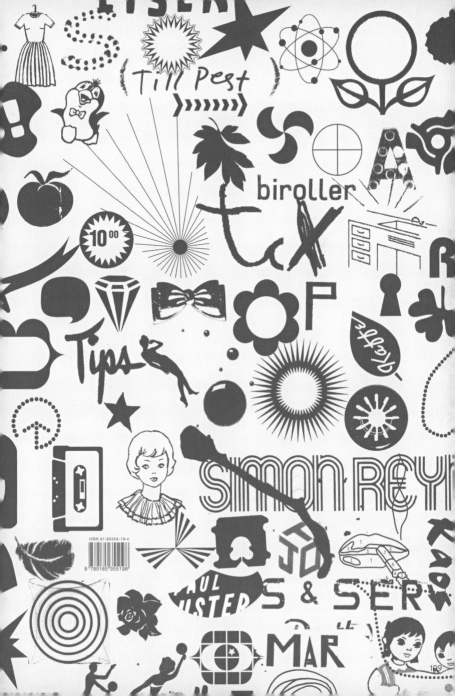

Till Pest

biroller

10.00

Tips

SIMON REY

PAUL AUSTER

S & SERV

MAR

ISBN 91-85355-19-4

9 789185 355198

109

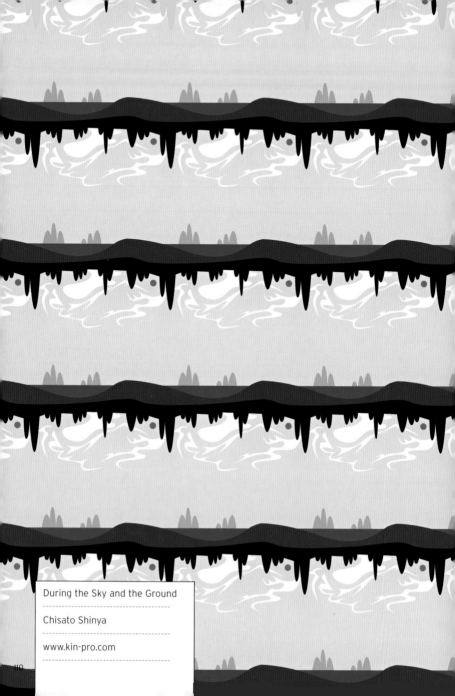

During the Sky and the Ground

Chisato Shinya

www.kin-pro.com

Glacier

Brit Hammer

www.brithammer.com

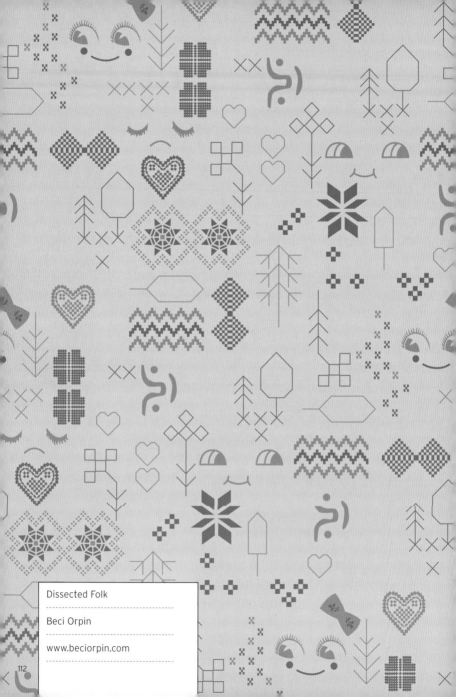

Dissected Folk

Beci Orpin

www.beciorpin.com

112

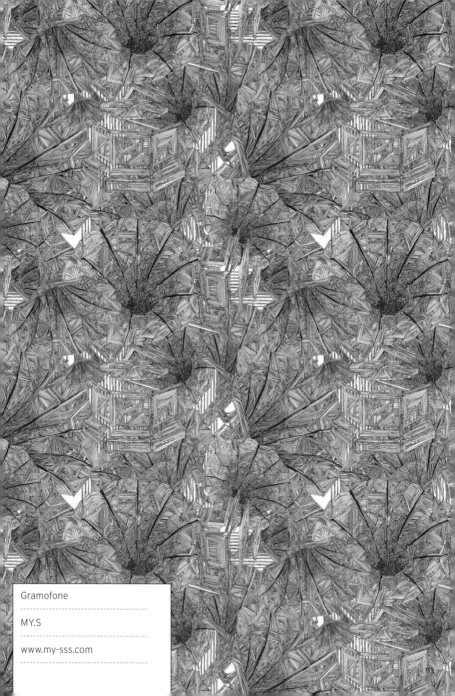

Gramofone

MY.S

www.my-sss.com

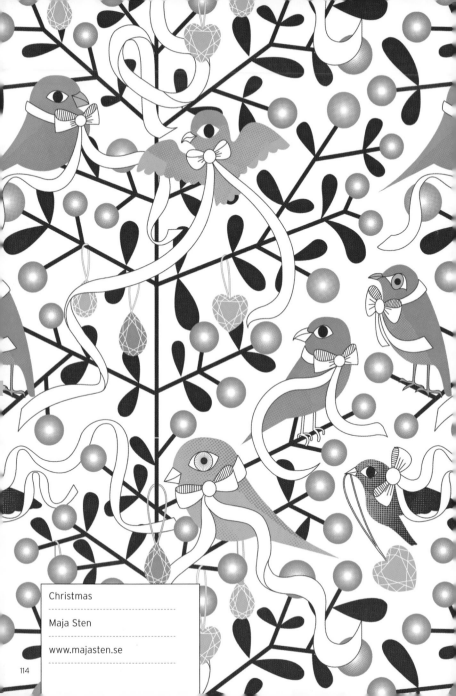

Christmas

Maja Sten

www.majasten.se

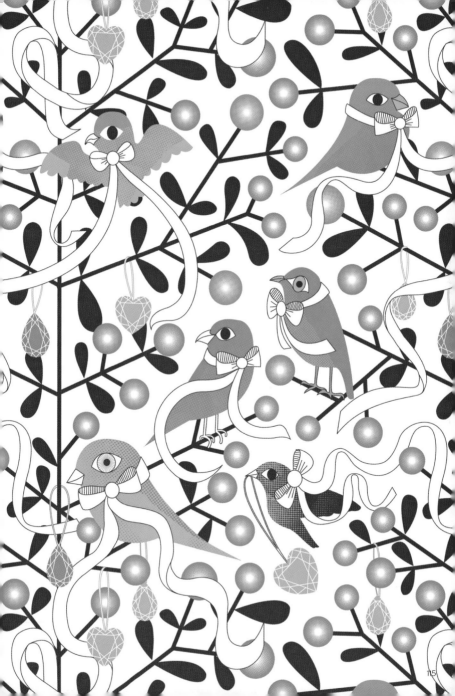

Hexagon for Ragwear

Sonia Chow & Huschang Pourian

www.chowpourian.com

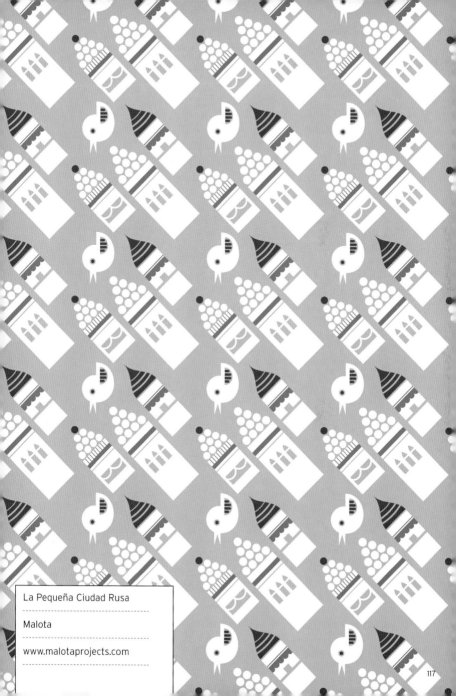

La Pequeña Ciudad Rusa

Malota

www.malotaprojects.com

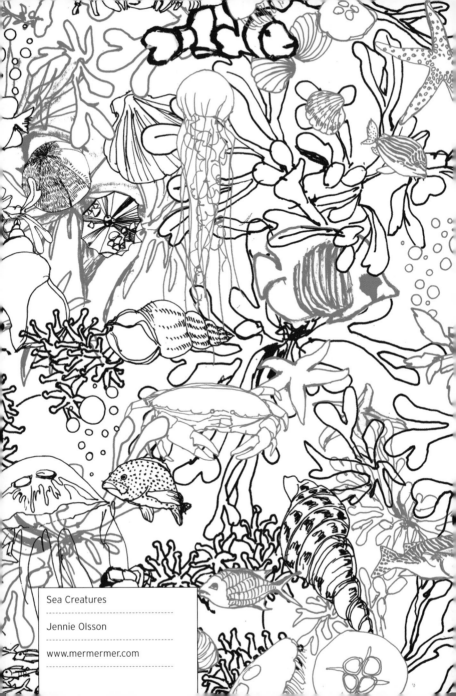

Sea Creatures

Jennie Olsson

www.mermermer.com

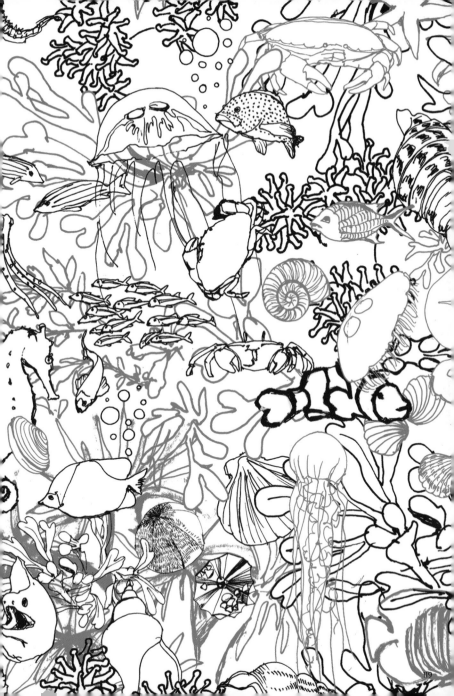

Maxi

Lisa Jones

www.lisajonescards.com

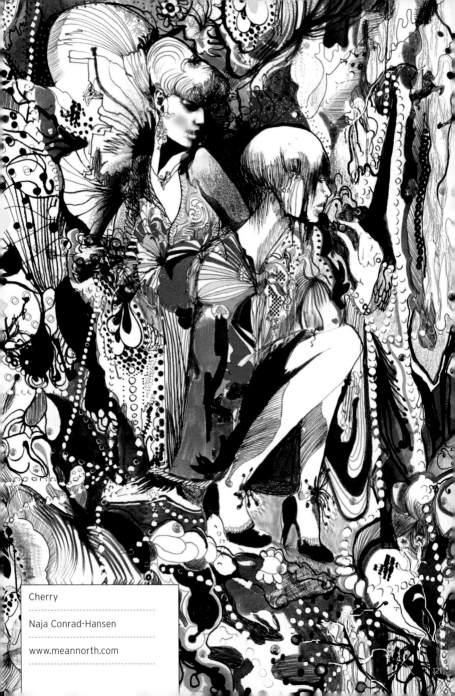

Cherry

Naja Conrad-Hansen

www.meannorth.com

Fasa Anit

Klaus Haapaniemi

www.klaush.com

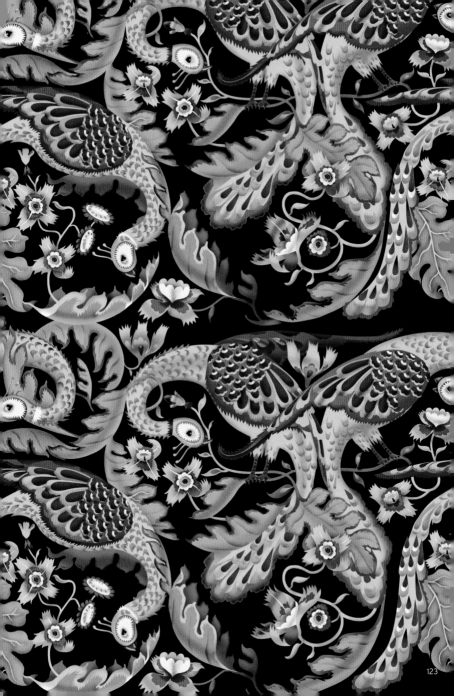

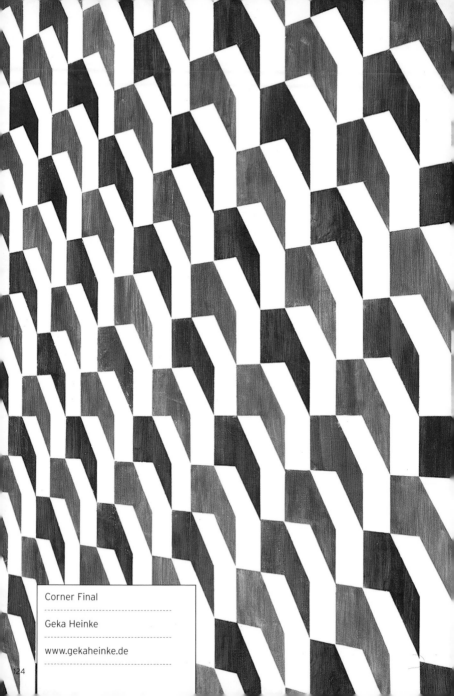

Corner Final

Geka Heinke

www.gekaheinke.de

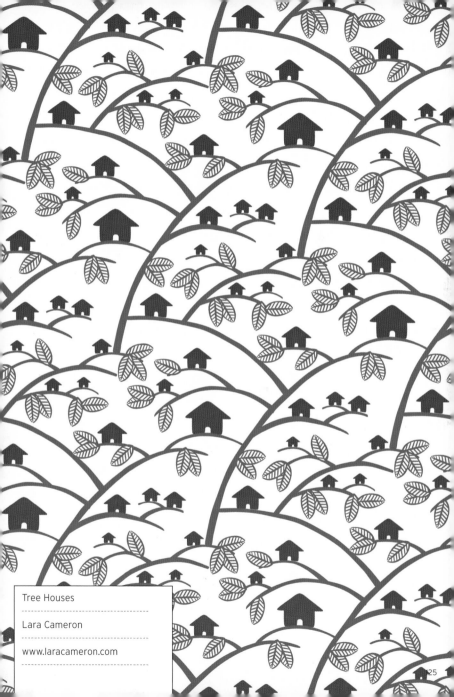

Tree Houses

Lara Cameron

www.laracameron.com

Blackbird

Carly Margolis

Owl

Eleanor Grosch

www.pushmepullyoudesign.com

127

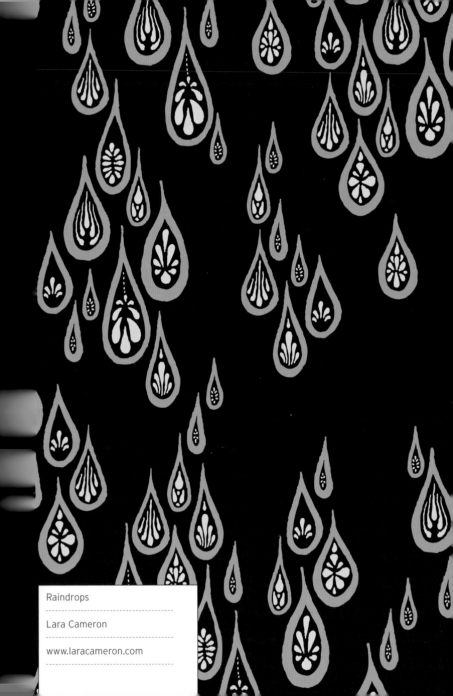

Raindrops

Lara Cameron

www.laracameron.com

Books

Natsko

www.natsko.com

Beams

Marcus James

www.marcusjames.co.uk

Plume

Carly Margolis

www.cavernhome.com

Claustrophobic Wallpaper 02

Geka Heinke

www.gekaheinke.de

Play Me

Ivana Helsinki

www.ivanahelsinki.com

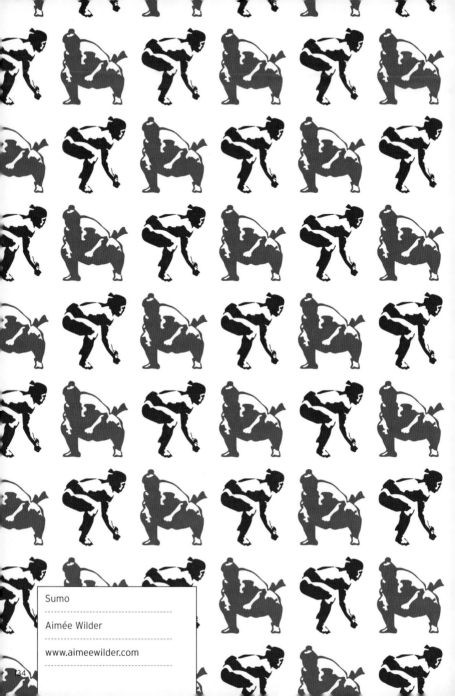

Sumo

Aimée Wilder

www.aimeewilder.com

Reflective Print

Eugène van Veldhover

www.dutchtextiledesign.com

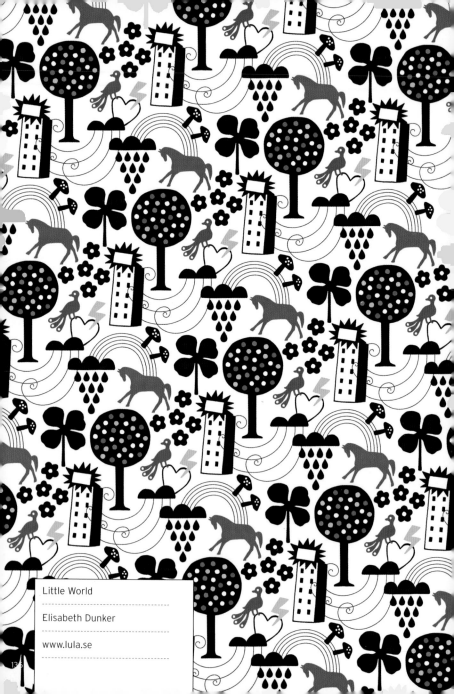

Little World

Elisabeth Dunker

www.lula.se

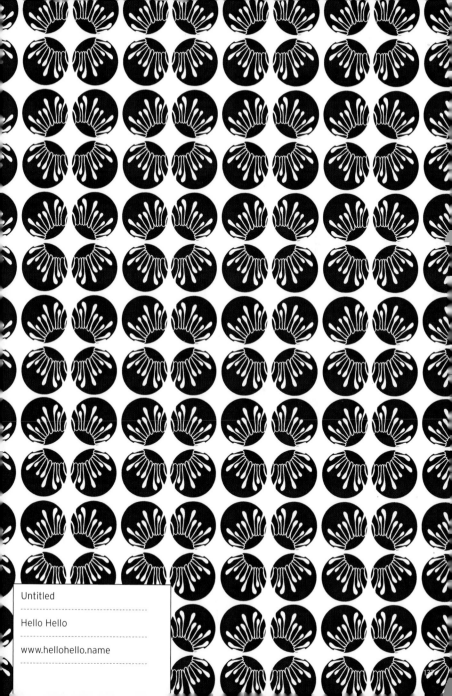

Untitled

Hello Hello

www.hellohello.name

Claustrophobic Wallpaper 01

Geka Heinke

www.gekaheinke.de

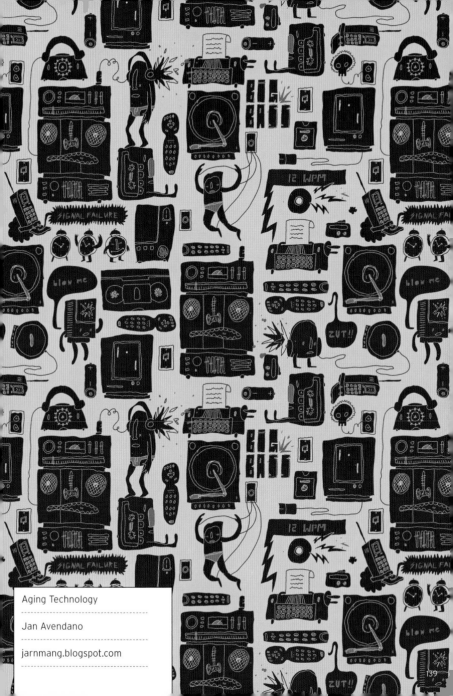

Aging Technology

Jan Avendano

jarnmang.blogspot.com

139

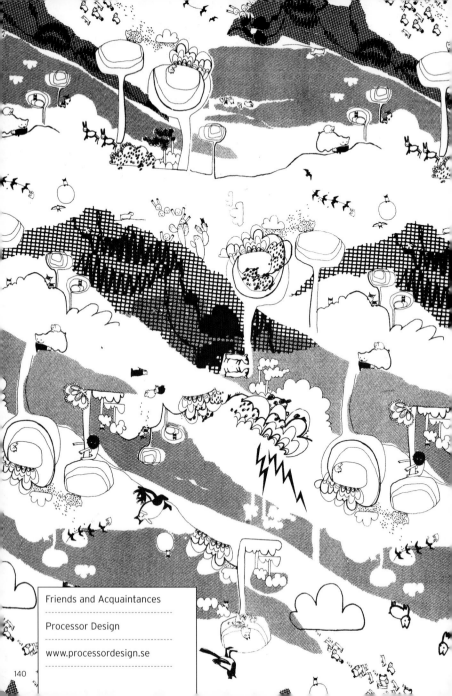

Friends and Acquaintances

Processor Design

www.processordesign.se

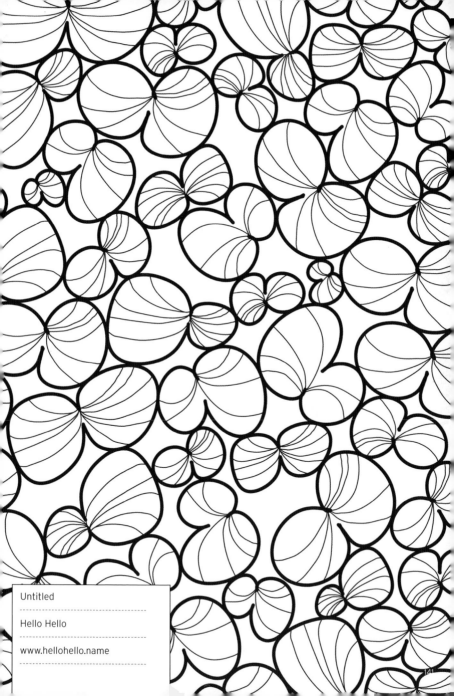

Untitled

Hello Hello

www.hellohello.name

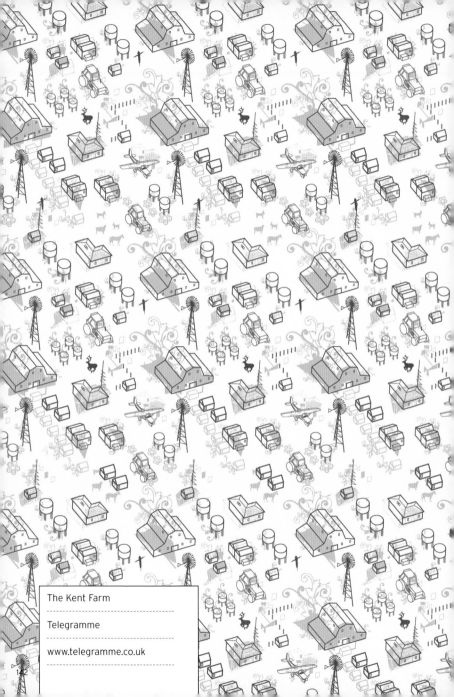

The Kent Farm

Telegramme

www.telegramme.co.uk

Migration

Carly Margolis

www.cavernhome.com

Leaf Lace

Lene Toni Kjeld

www.walldecoration.dk

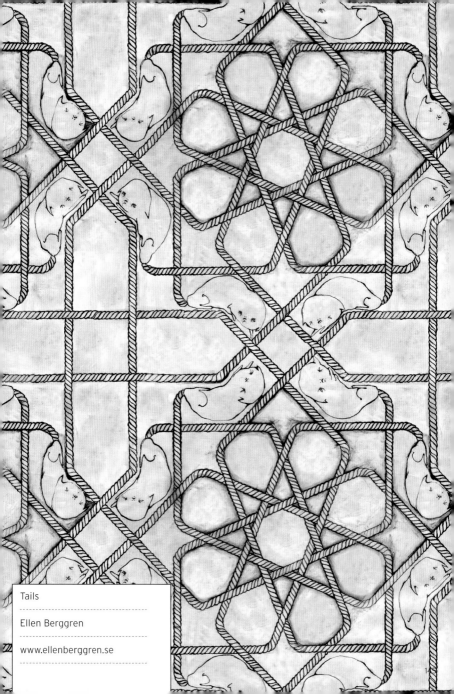

Tails

Ellen Berggren

www.ellenberggren.se

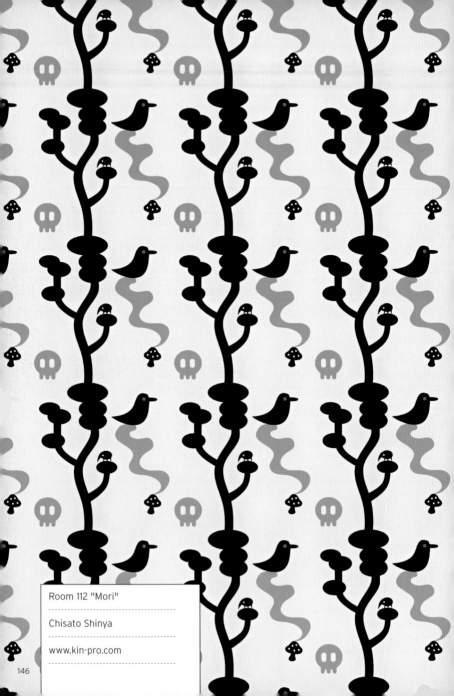

Room 112 "Mori"

Chisato Shinya

www.kin-pro.com

Looking for the Water

Cloth Fabric

www.clothfabric.com

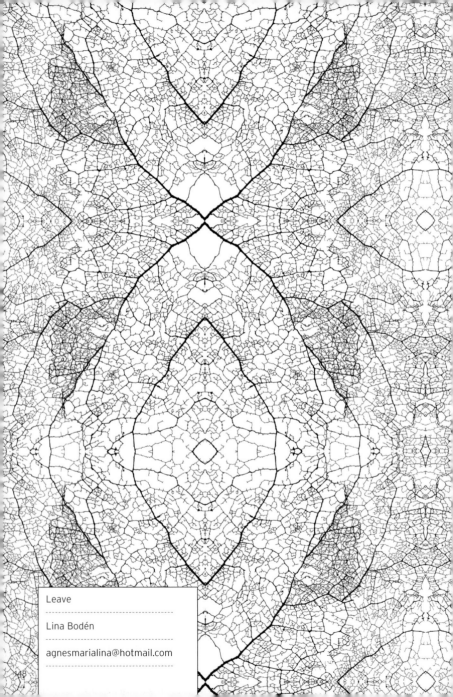

Leave

Lina Bodén

agnesmarialina@hotmail.com

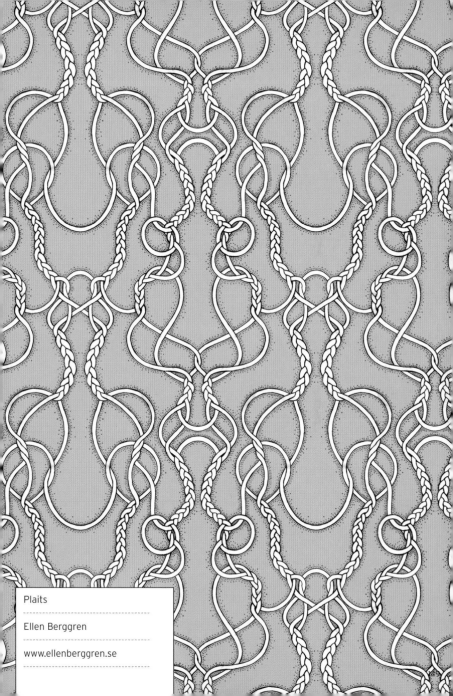

Plaits

Ellen Berggren

www.ellenberggren.se

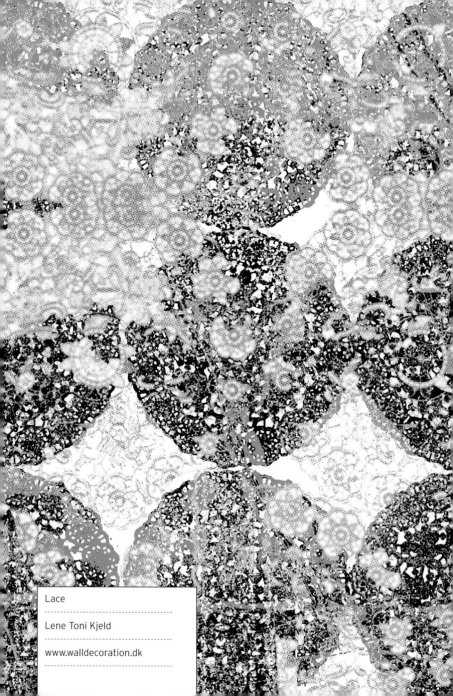

Lace

Lene Toni Kjeld

www.walldecoration.dk

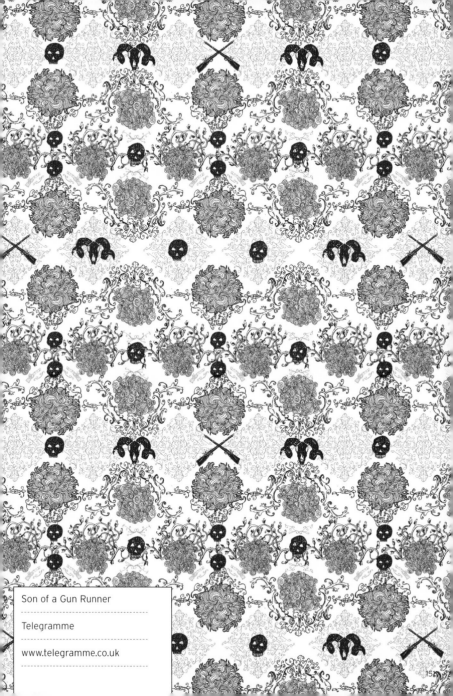

Son of a Gun Runner

Telegramme

www.telegramme.co.uk

151

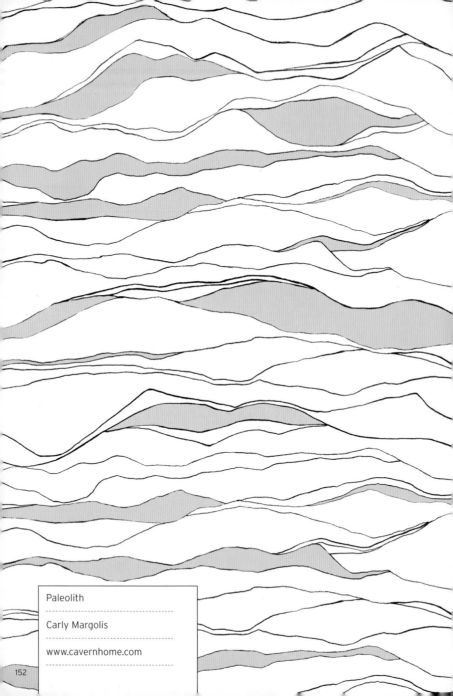

Paleolith

Carly Margolis

www.cavernhome.com

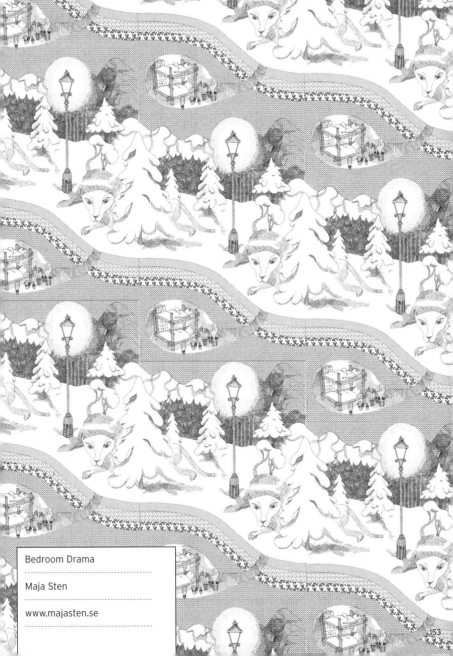

Bedroom Drama

Maja Sten

www.majasten.se

153

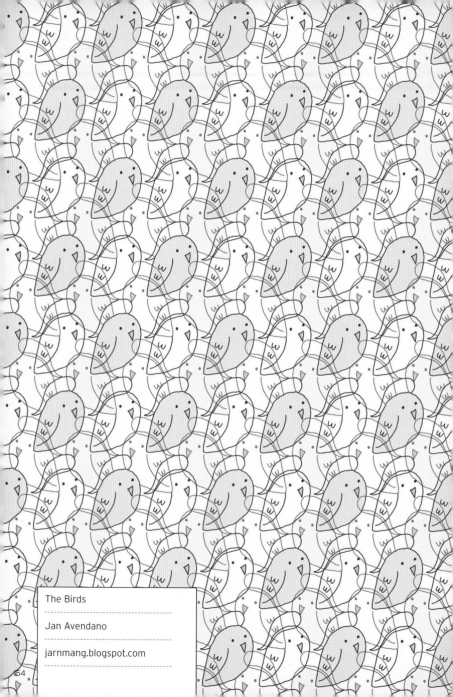

The Birds

Jan Avendano

jarnmang.blogspot.com

Snowflake Pink

Marcel Wanders

www.marcelwanders.com

Ironico Textil

Beci Orpin

www.beciorpin.com

Sequins

Tracy Kendall

www.tracykendall.com

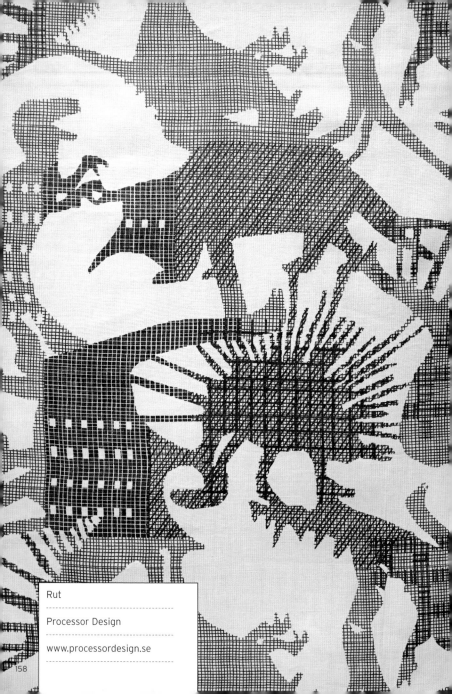

Rut

Processor Design

www.processordesign.se

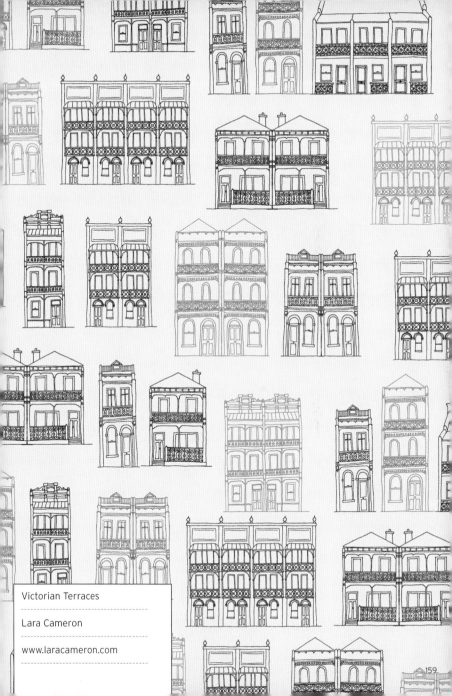

Victorian Terraces

Lara Cameron

www.laracameron.com

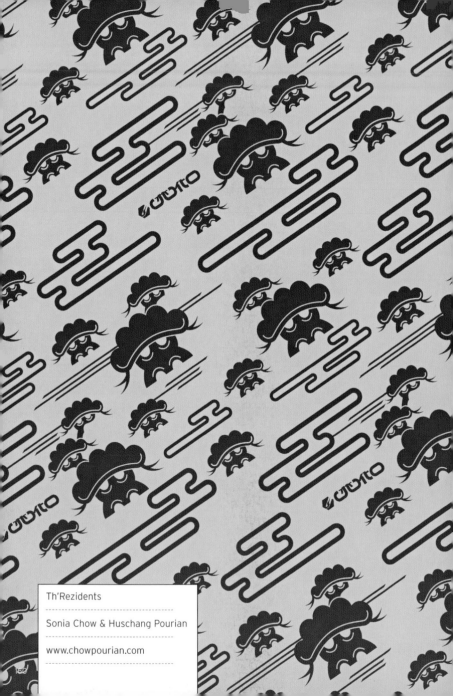

Th'Rezidents

--

Sonia Chow & Huschang Pourian

--

www.chowpourian.com

--

Technical Camouflage

Sonia Chow & Huschang Pourian

www.chowpourian.com

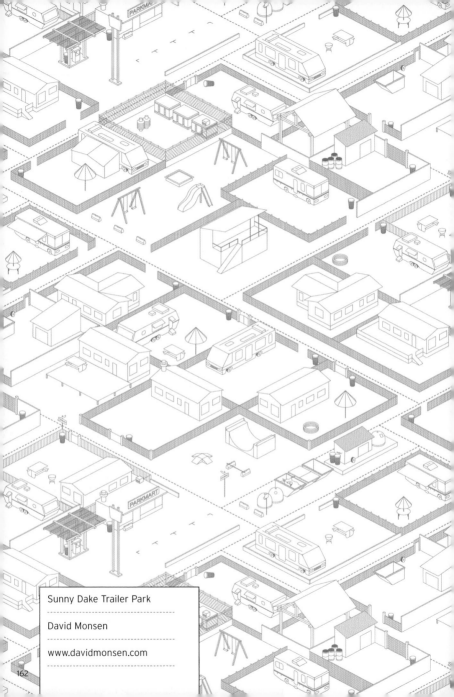

Sunny Dake Trailer Park

David Monsen

www.davidmonsen.com

162

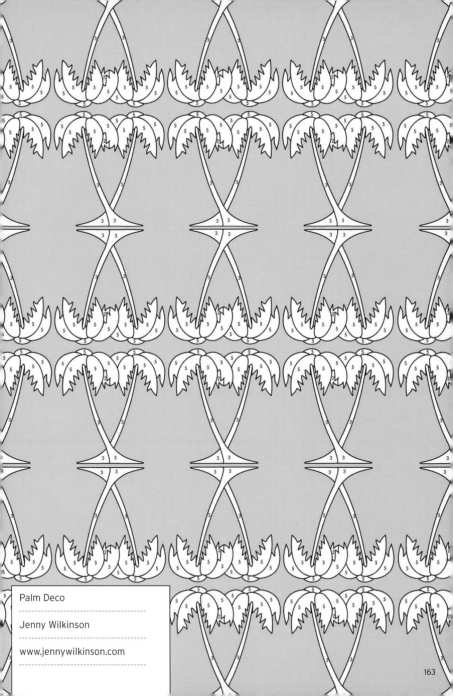

Palm Deco

Jenny Wilkinson

www.jennywilkinson.com

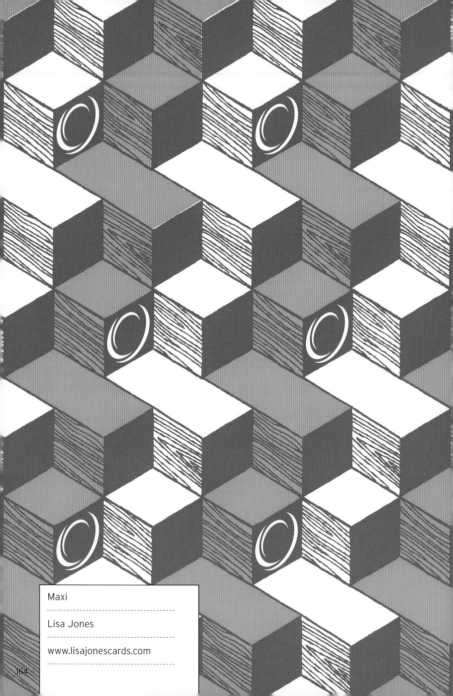

Maxi

Lisa Jones

www.lisajonescards.com

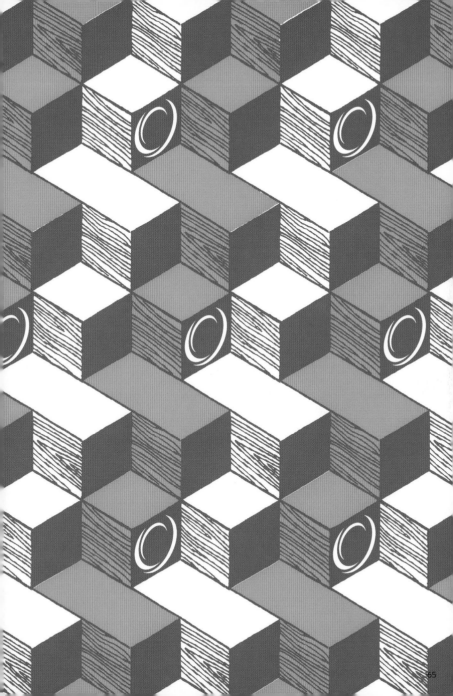

Circus Balls

Aimée Wilder

www.aimeewilder.com

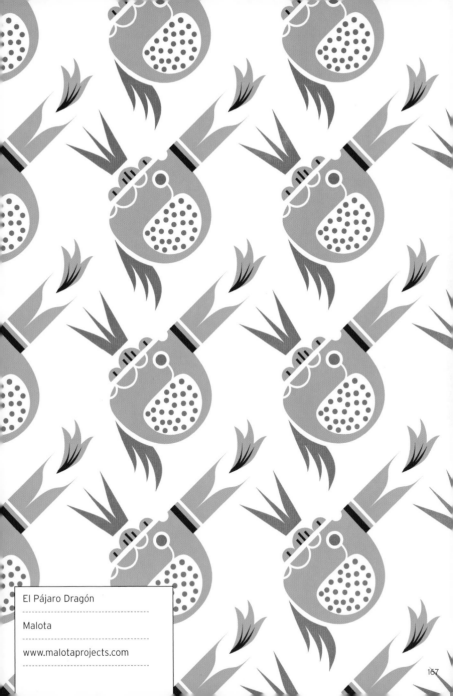

El Pájaro Dragón

Malota

www.malotaprojects.com

Hibisco

MY.S

www.my-sss.com

Boardwalk

Cloth Fabric

www.clothfabric.com

Garden of Foo

Me Company

www.mecompany.com

Spotcheck

Cloth Fabric

www.clothfabric.com

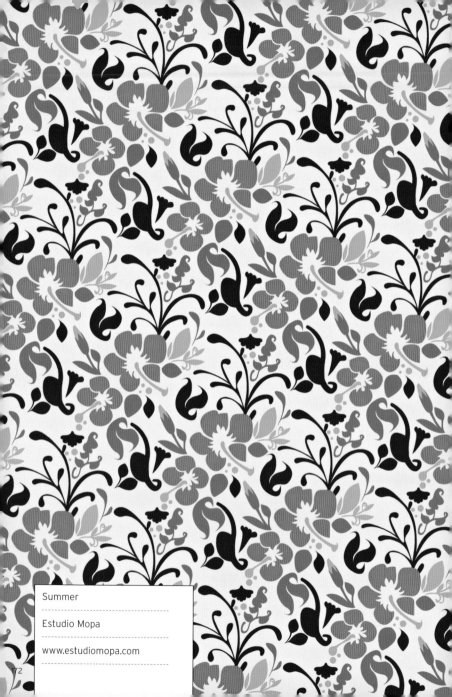

Summer

Estudio Mopa

www.estudiomopa.com

Bloom

Helen Amy Murray

www.helenamymurray.com

Camouflage

Mina Wu

www.wretch.cc/blog/minawu

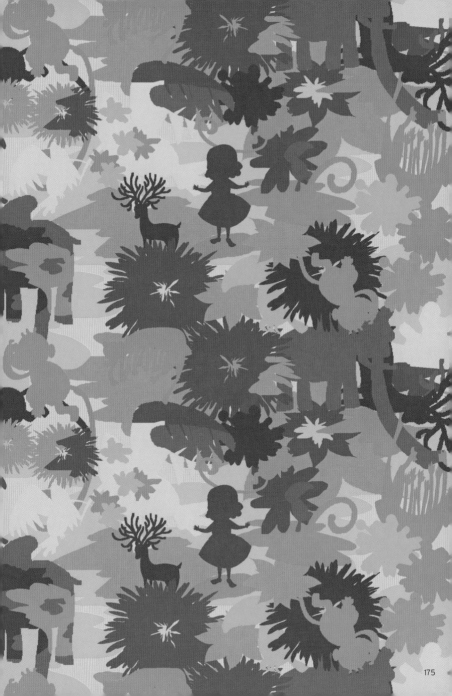

End Paper

Beci Orpin

www.beciorpin.com

176

Swiss Family Robinson

Telegramme

www.telegramme.co.uk

Redwood Sorrel

Jill Bliss

www.jillbliss.com

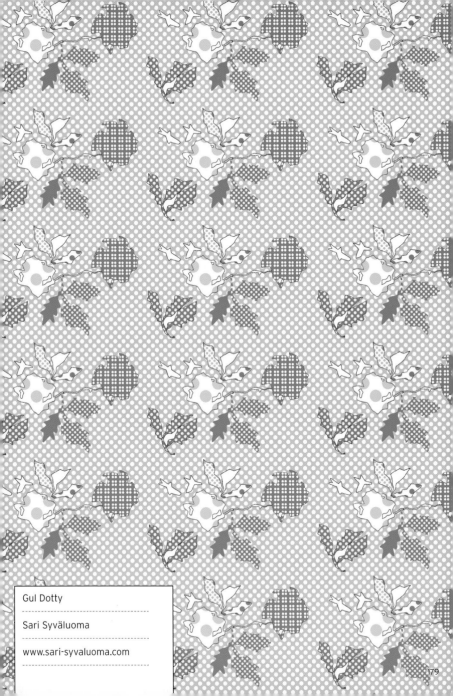

Gul Dotty

Sari Syväluoma

www.sari-syvaluoma.com

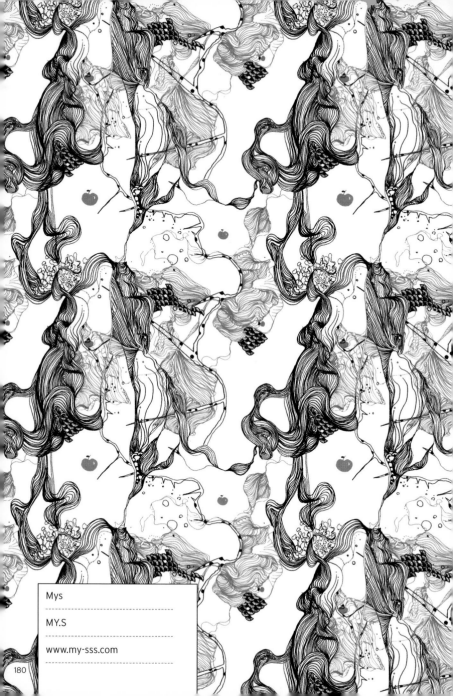

Mys

MY.S

www.my-sss.com

Guns

Koldbrand

www.koldbrand.com

Monster Truck Safari

Grand Array

www.grandarray.com

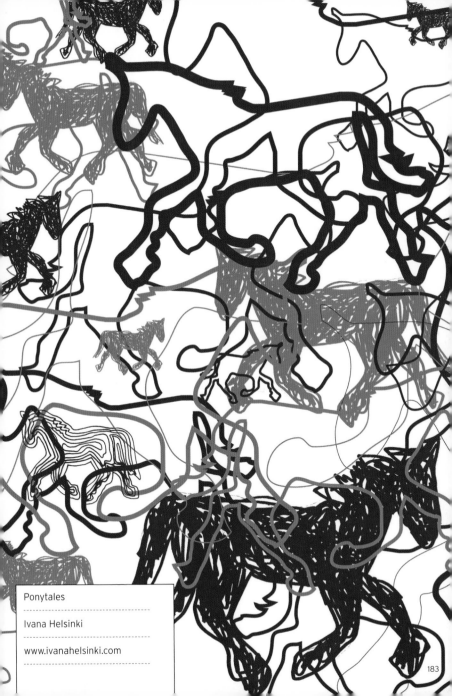

Ponytales

Ivana Helsinki

www.ivanahelsinki.com

Frog

Estudio Mopa

www.estudiomopa.com

Parrot

Eleanor Grosch

www.pushmepullyoudesign.com

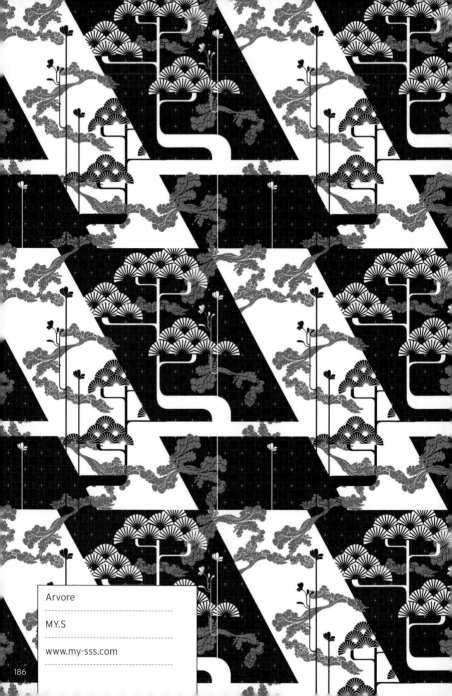

Arvore

MY.S

www.my-sss.com

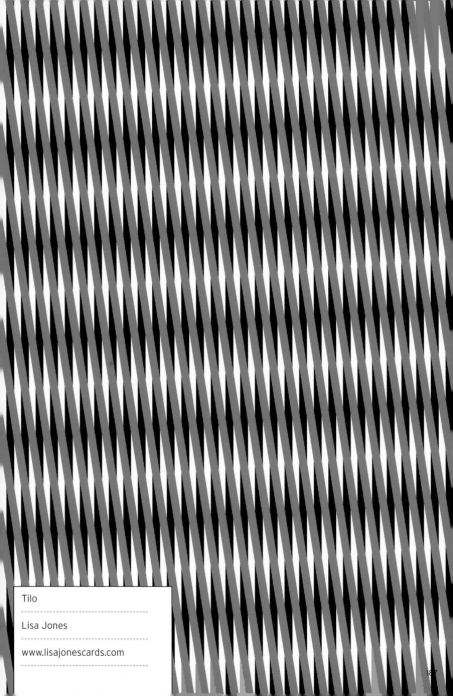

Tilo

Lisa Jones

www.lisajonescards.com

Boy, Girl

Catalina Estrada

www.catalinaestrada.com

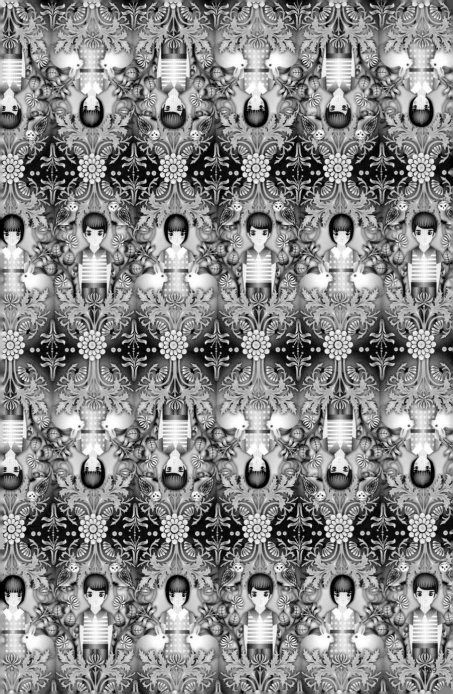

Dance of Life

Brit Hammer

www.brithammer.com

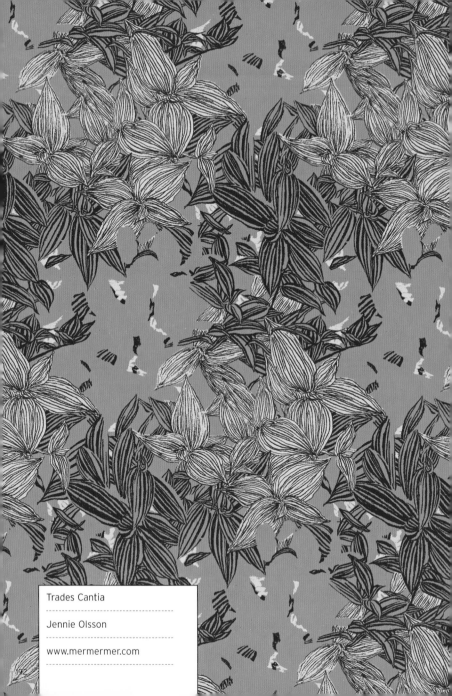

Trades Cantia

Jennie Olsson

www.mermermer.com

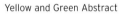

Yellow and Green Abstract

Alice Stevenson

www.alicestevenson.com

Loghouse

Ivana Helsinki

www.ivanahelsinki.com

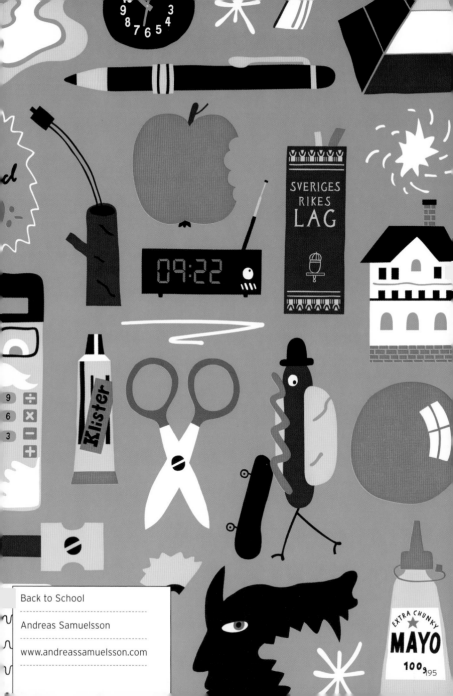

SVERIGES
RIKES
LAG

09:22

EXTRA CHUNKY
MAYO
100g

Back to School

Andreas Samuelsson

www.andreassamuelsson.com

Tytöt

Ivana Helsinki

www.ivanahelsinki.com

Time to Imagine It

Chisato Shinya

www.kin-pro.com

Peaflock

Carly Margolis

www.cavernhome.com

Pip

Hello Monday

www.hellomonday.net

Knoppar

Ellen Berggren

www.ellenberggren.se

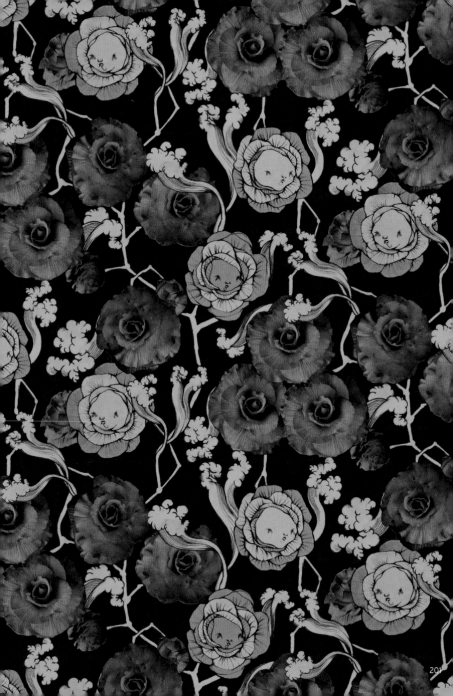

Benita

Extratapete

www.extratapete.de

Watercolors

Malota

www.malotaprojects.com

Askar 1

Ellen Berggren

www.ellenberggren.se

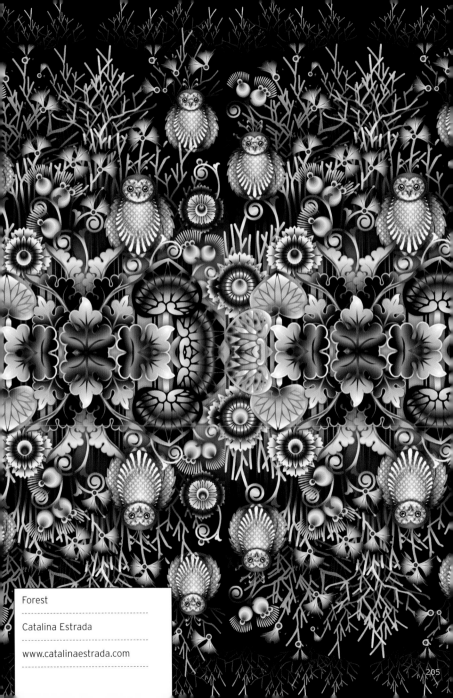

Forest

Catalina Estrada

www.catalinaestrada.com

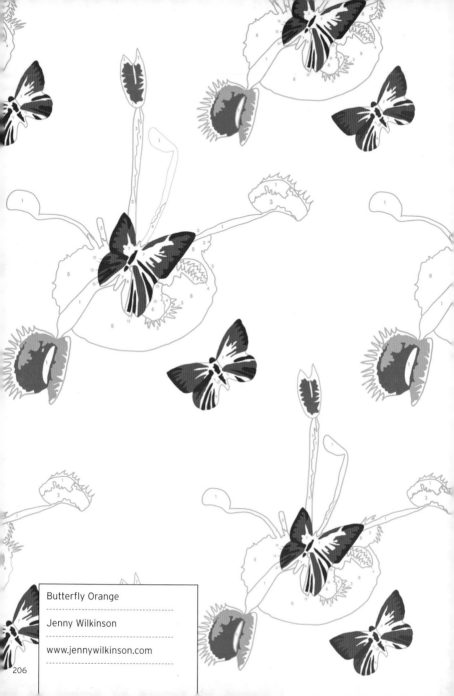

Butterfly Orange

Jenny Wilkinson

www.jennywilkinson.com

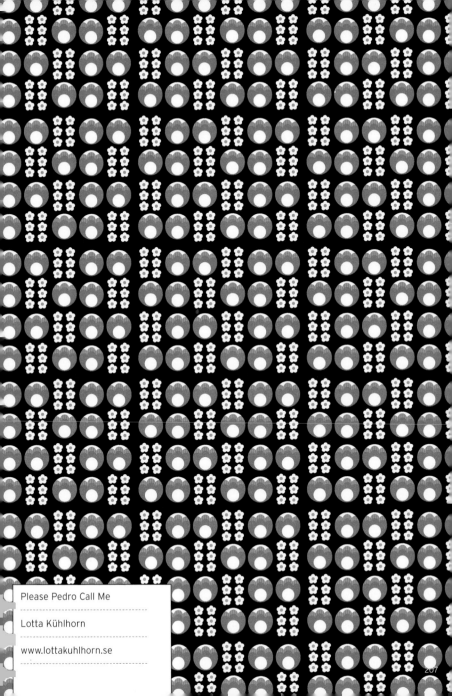

Please Pedro Call Me

Lotta Kühlhorn

www.lottakuhlhorn.se

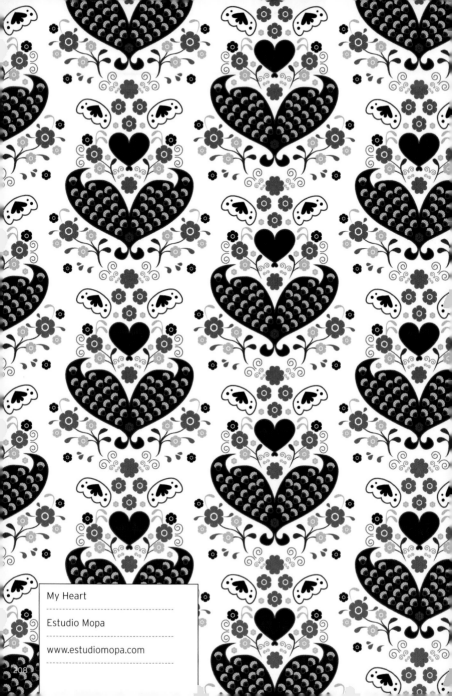

My Heart

Estudio Mopa

www.estudiomopa.com

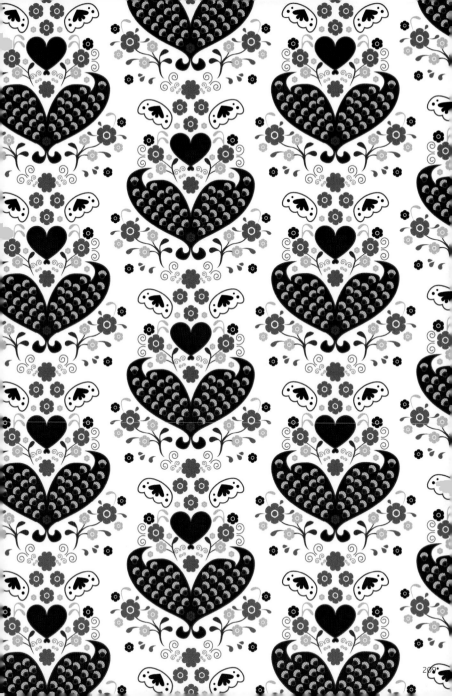

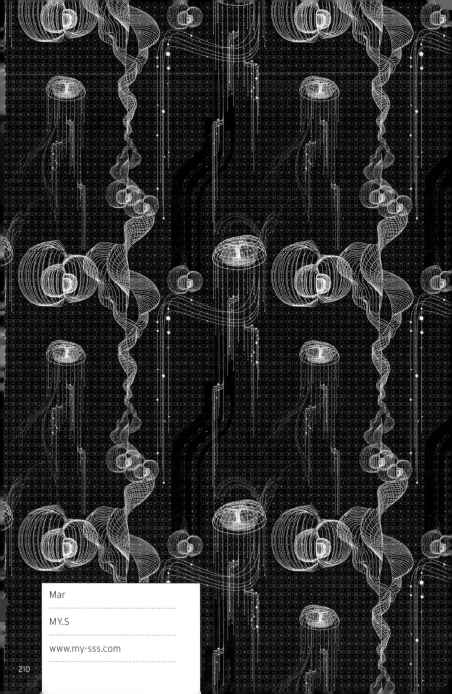

Mar

MY.S

www.my-sss.com

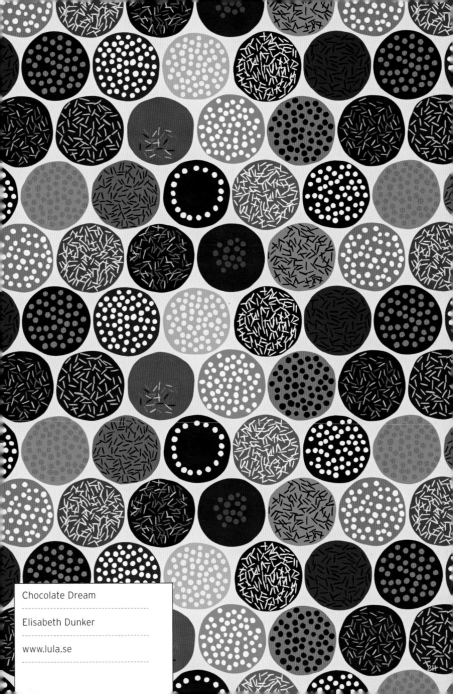

Chocolate Dream

Elisabeth Dunker

www.lula.se

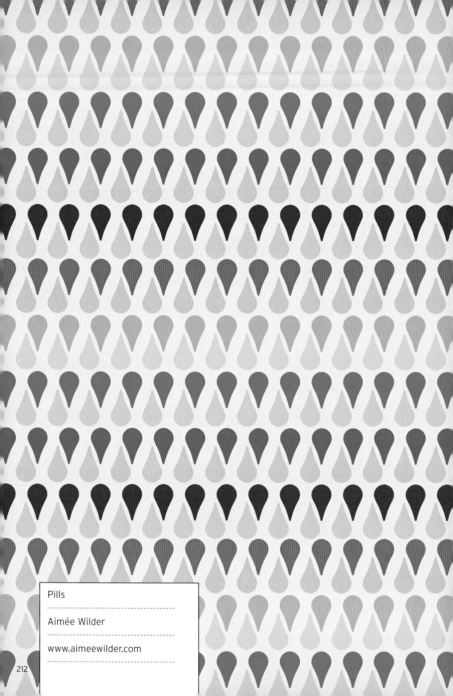

Pills

Aimée Wilder

www.aimeewilder.com

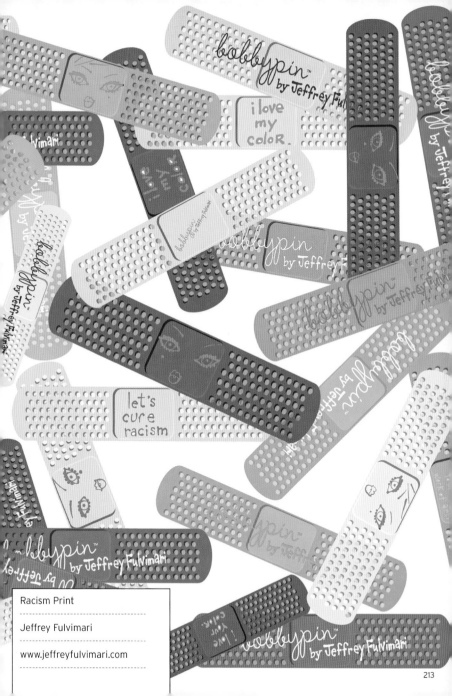

Racism Print

Jeffrey Fulvimari

www.jeffreyfulvimari.com

Ladyfest

Hvass & Hannibal

www.hvasshannibal.dk

Rutan

Lotta Kühlhorn

www.lottakuhlhorn.se

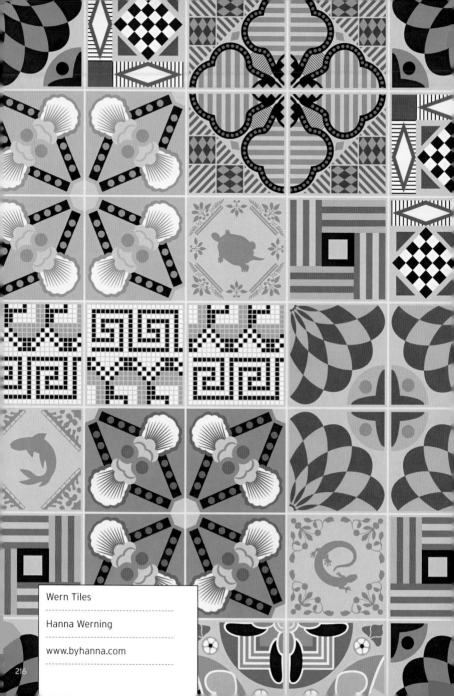

Wern Tiles

Hanna Werning

www.byhanna.com

Djurtradgard

Hanna Werning

www.byhanna.com

Genetic Politic

Me Company

www.mecompany.com

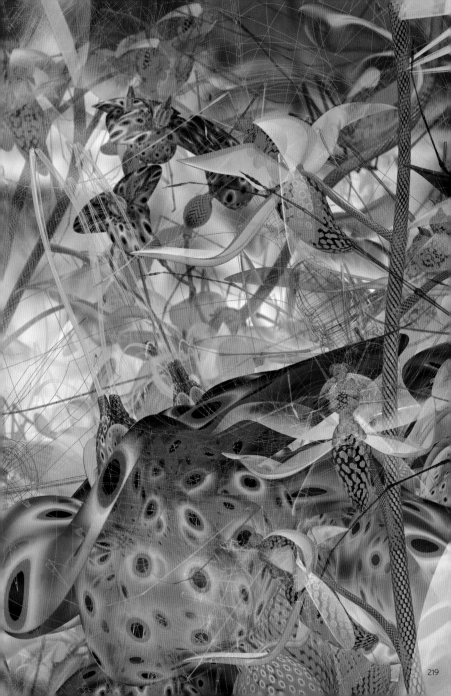

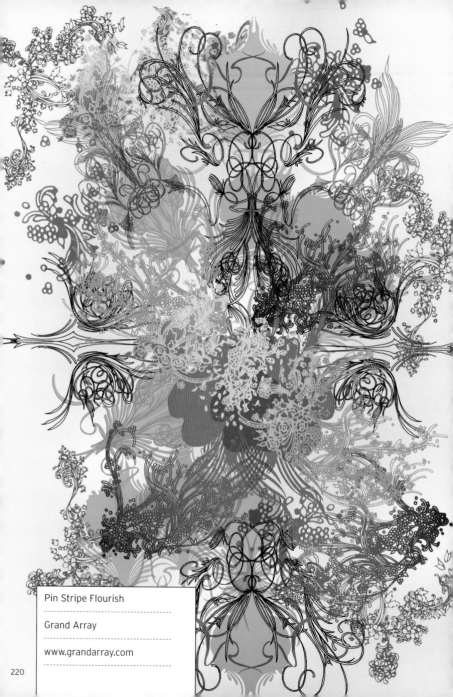

Pin Stripe Flourish

Grand Array

www.grandarray.com

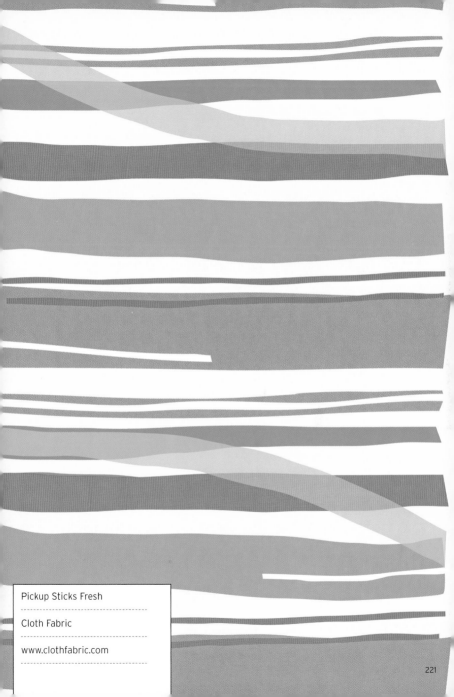

Pickup Sticks Fresh

Cloth Fabric

www.clothfabric.com

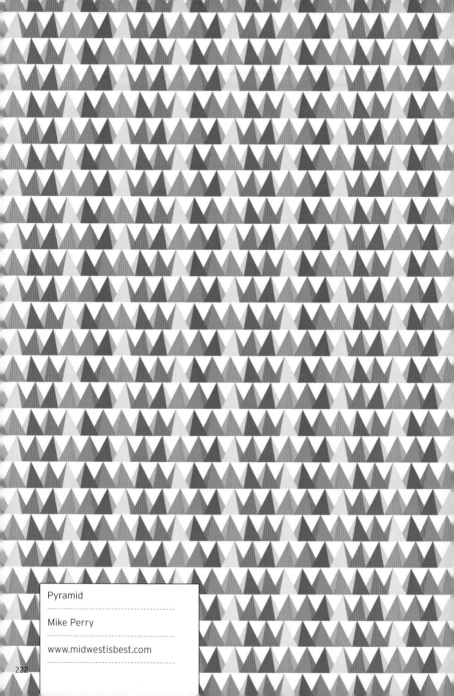

Pyramid

Mike Perry

www.midwestisbest.com

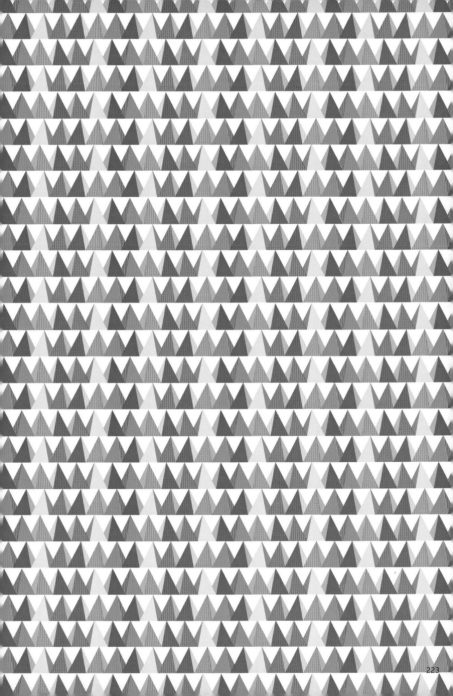

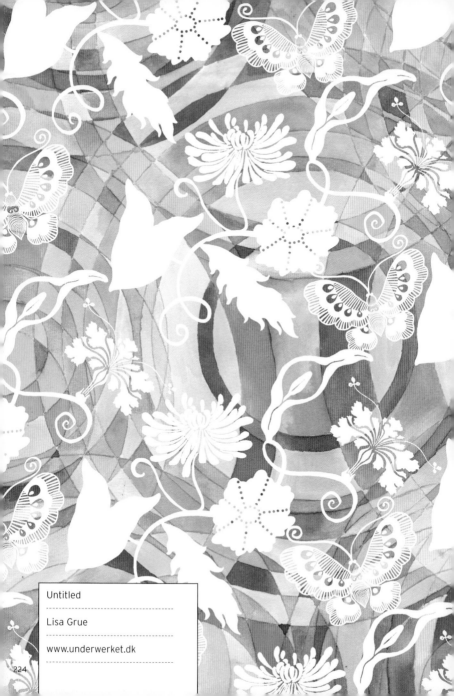

Untitled

Lisa Grue

www.underwerket.dk

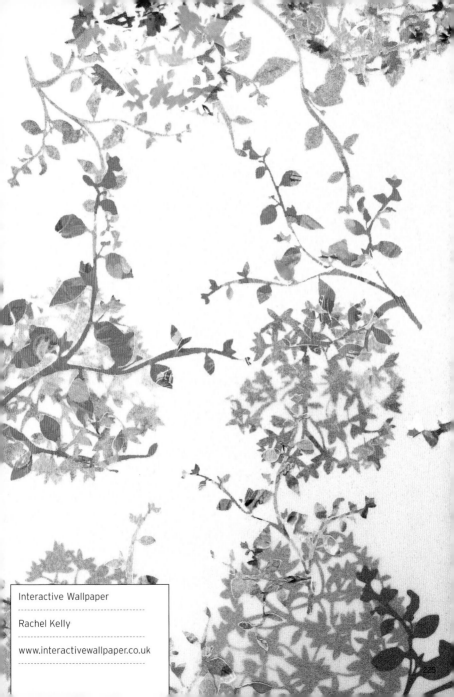

Interactive Wallpaper

Rachel Kelly

www.interactivewallpaper.co.uk

Bambi

Catalina Estrada

www.catalinaestrada.com

Birds

Julia Pelletier

www.juliapelletier.com

Dots Obsession New Century

Yayoi Kusama

www.yayoi-kusama.jp

LSD

Henrik Vibskov

www.henrikvibskov.com

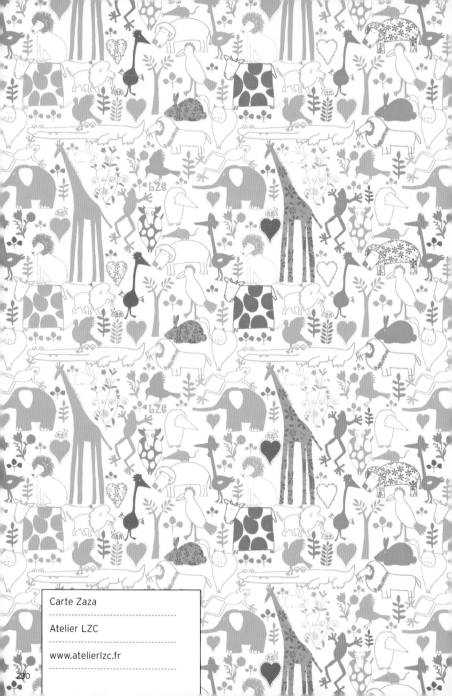

Carte Zaza

Atelier LZC

www.atelierlzc.fr

Soap

Paulina Reyes

www.paulinareyes.com

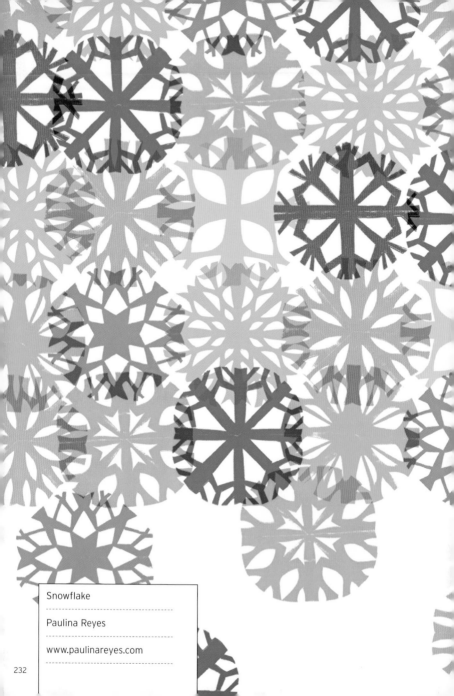

Snowflake

Paulina Reyes

www.paulinareyes.com

Ribbon

Studio Job

www.studiojob.nl

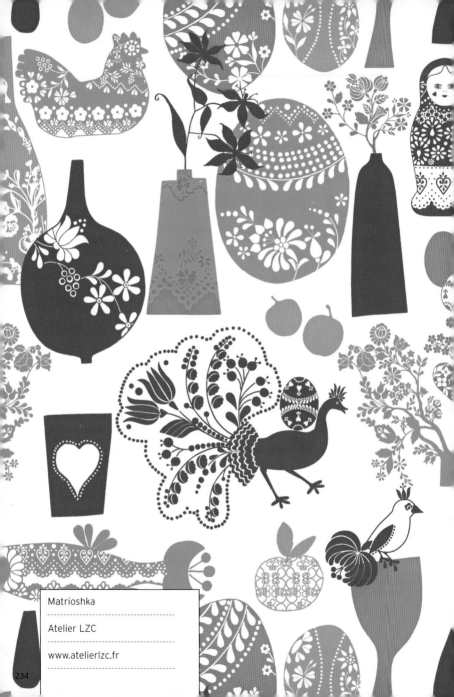

Matrioshka

Atelier LZC

www.atelierlzc.fr

234

Trees

David Monsen

www.davidmonsen.com

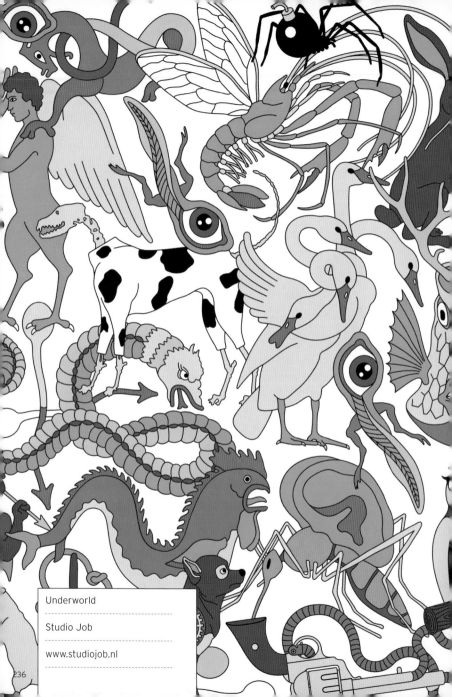

Underworld

Studio Job

www.studiojob.nl

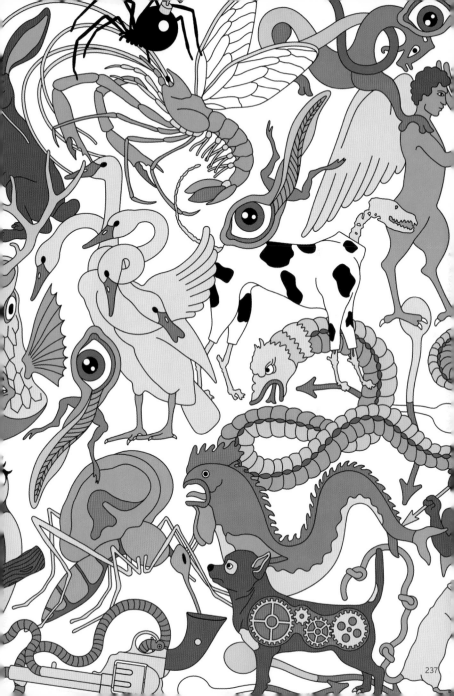

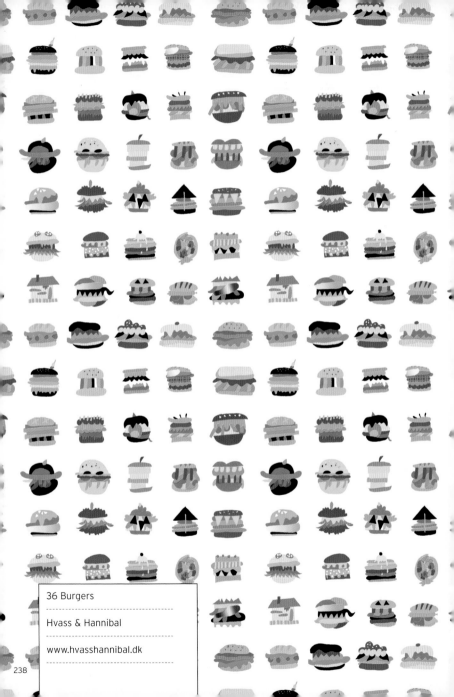

36 Burgers

Hvass & Hannibal

www.hvasshannibal.dk

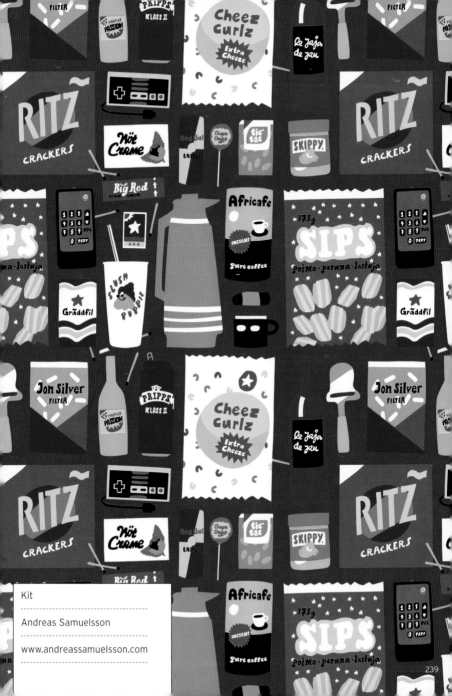

Kit

Andreas Samuelsson

www.andreassamuelsson.com

239

Children's Books

Natsko

www.natsko.com

11 new

Children's Books

guide

Zebraskog

Hanna Werning

www.byhanna.com

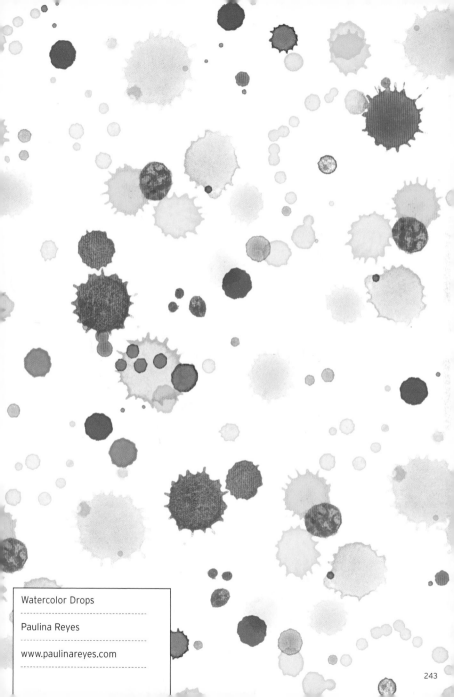

Watercolor Drops

Paulina Reyes

www.paulinareyes.com

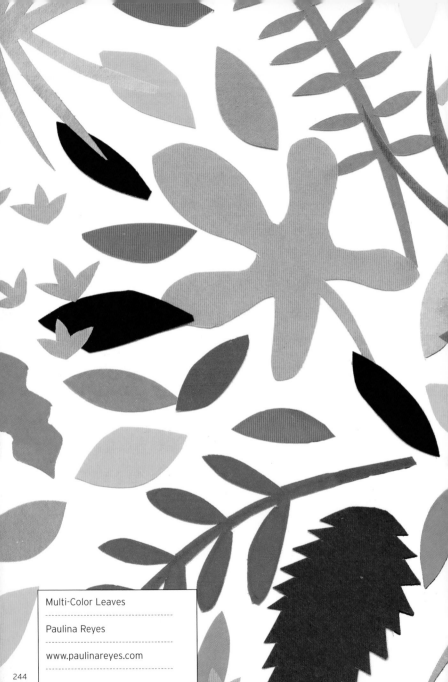

Multi-Color Leaves

Paulina Reyes

www.paulinareyes.com

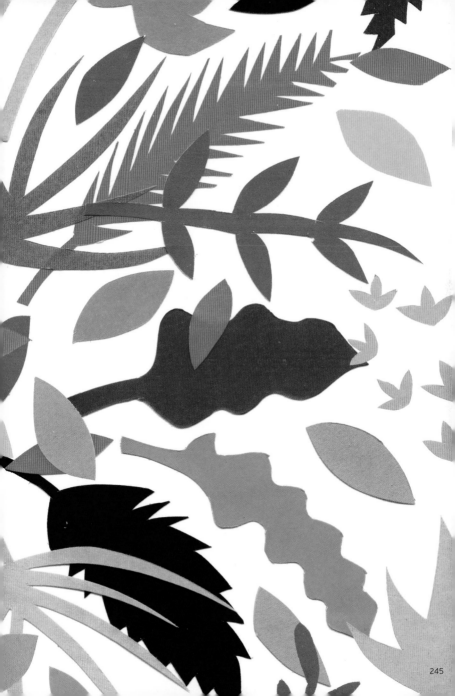

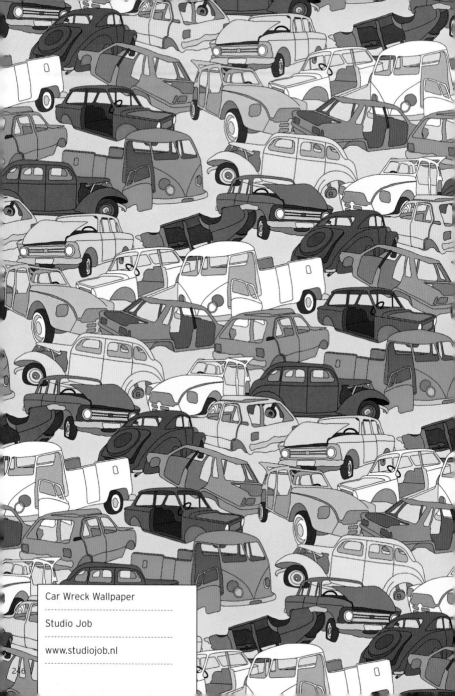

Car Wreck Wallpaper

Studio Job

www.studiojob.nl

Logo Floral

Simone Jessup

www.simonejessup.com

Watercolor Bids

Paulina Reyes

www.paulinareyes.com

Clouds

Jennie Olsson

www.mermermer.com

Dreams of Hawaii

Hvass & Hannibal

www.hvasshannibal.dk

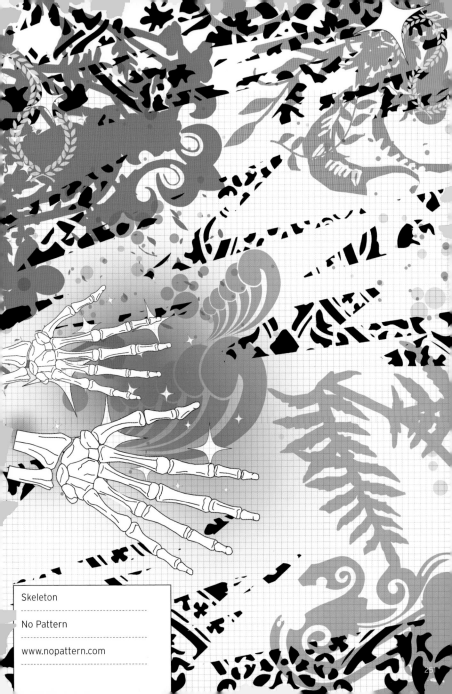

Skeleton

No Pattern

www.nopattern.com

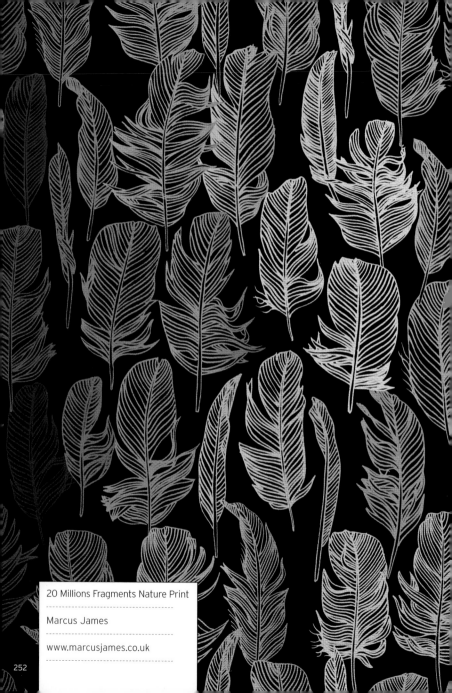

20 Millions Fragments Nature Print

Marcus James

www.marcusjames.co.uk

Chem

David Monsen

www.davidmonsen.com

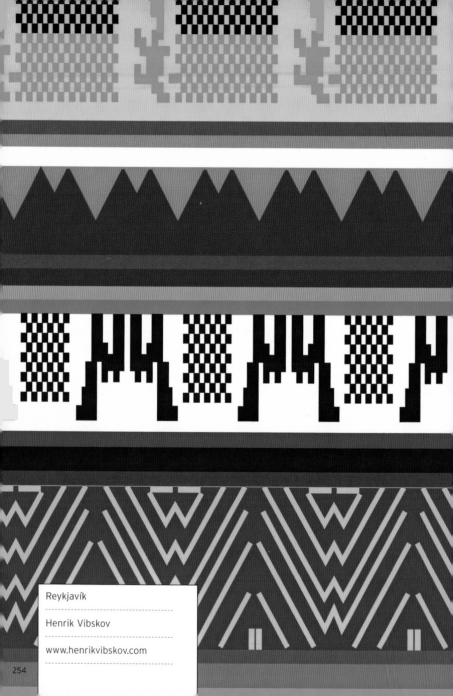

Reykjavík

Henrik Vibskov

www.henrikvibskov.com

254

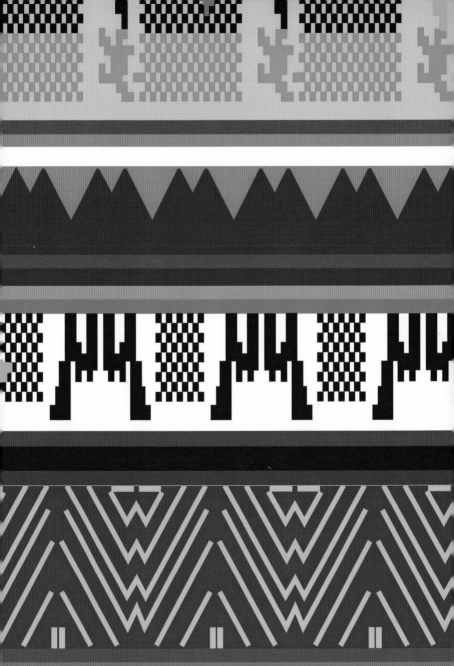

255

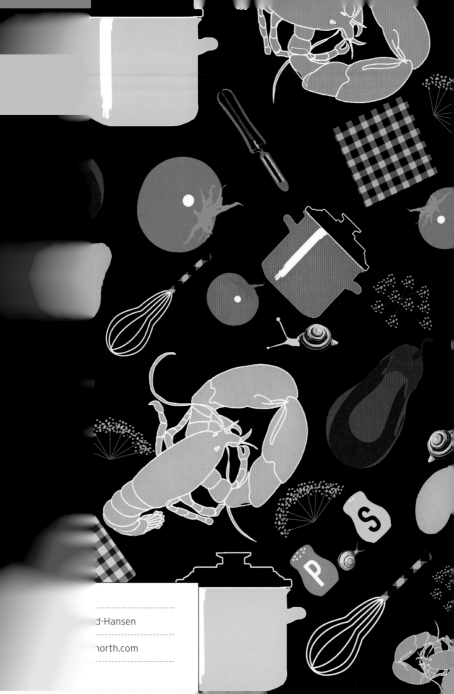

d-Hansen

north.com

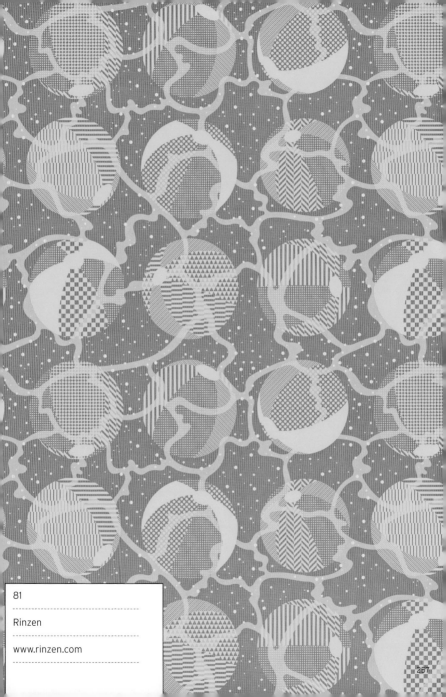

81

Rinzen

www.rinzen.com

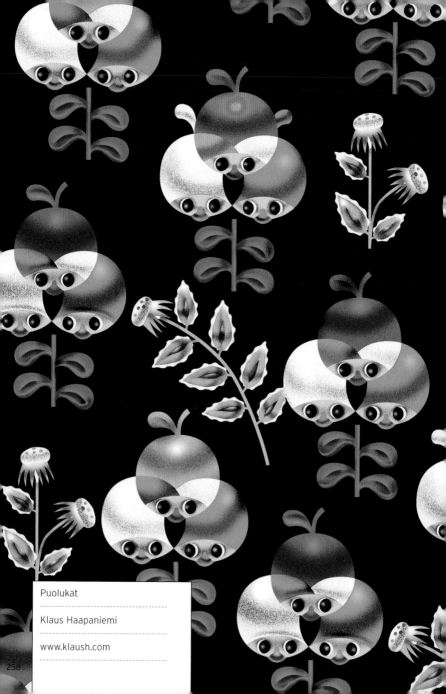

Puolukat

Klaus Haapaniemi

www.klaush.com

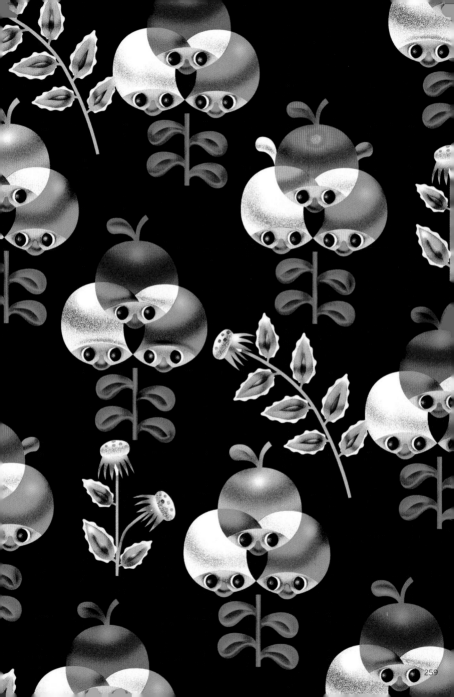

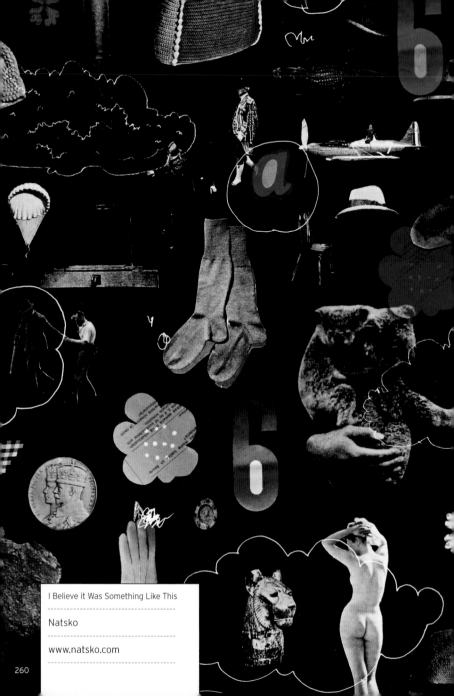

I Believe it Was Something Like This

Natsko

www.natsko.com

Datalogi

Hvass & Hannibal

www.hvasshannibal.dk

Preen

Kustaa Saksi

www.kustaasaksi.com

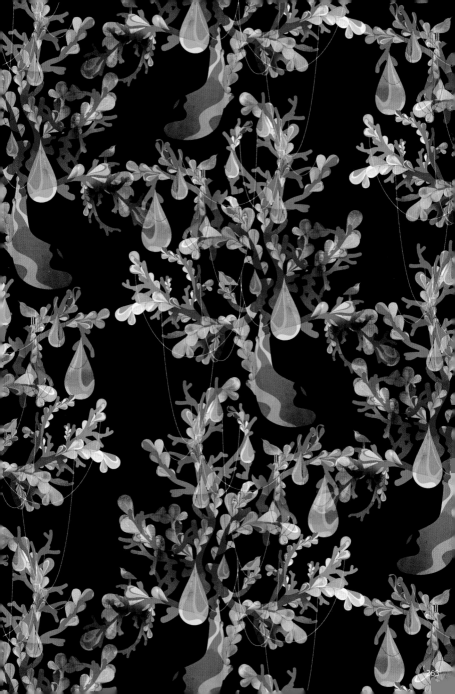

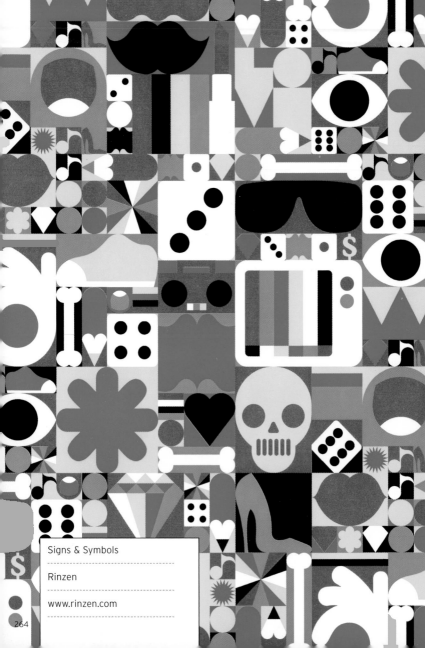

Signs & Symbols

Rinzen

www.rinzen.com

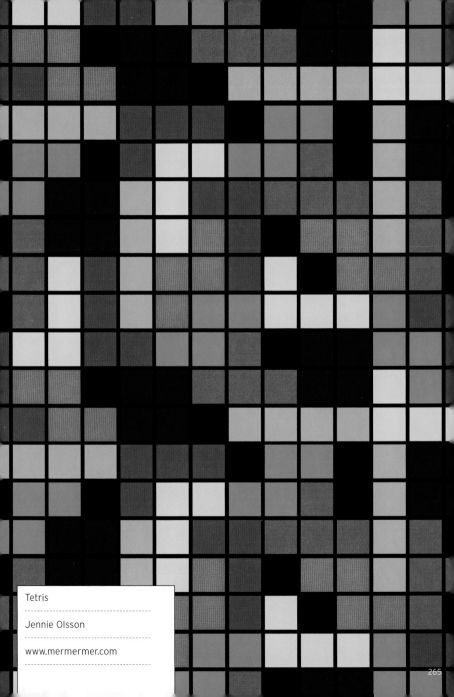

Tetris

Jennie Olsson

www.mermermer.com

Shapes Red

Eley Kishimoto

www.eleykishimoto.com

Marbles Black

Eley Kishimoto

www.eleykishimoto.com

A Feeling Happy

Chisato Shinya

www.kin-pro.com

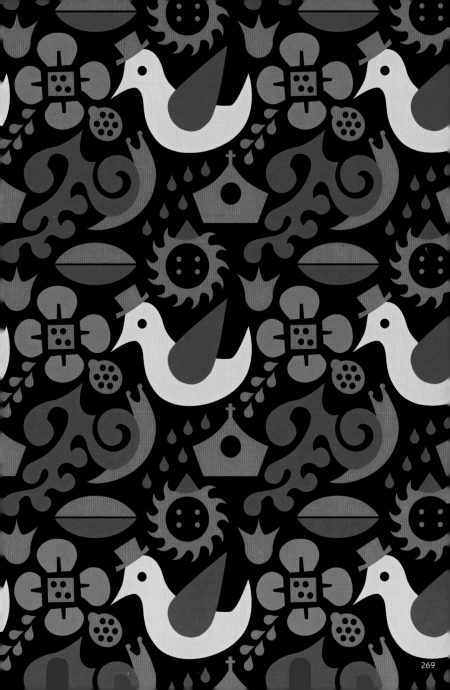

Physidelic

Mark Dean Veca

www.markdeanveca.com

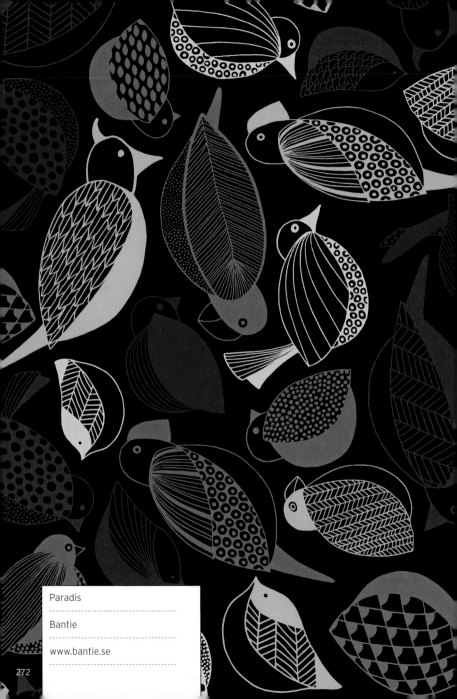

Paradis

Bantie

www.bantie.se

Leaf Wallpaper

Anne Kyyrö Quinn

www.annekyyroquinn.com

Dark Print

Marcus James

www.marcusjames.co.uk

El Bosque

Malota

www.malotaprojects.com

Underground Allover

Beci Orpin

www.beciorpin.com

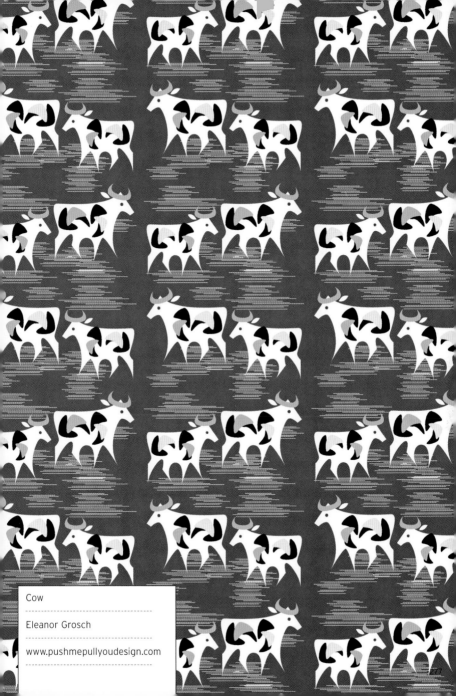

Cow

Eleanor Grosch

www.pushmepullyoudesign.com

Golly Gosh

Deuce Design

www.deucedesign.com.au

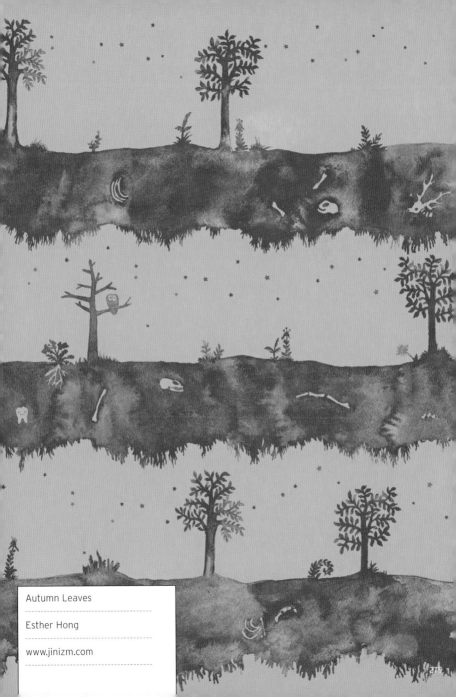

Autumn Leaves

Esther Hong

www.jinizm.com

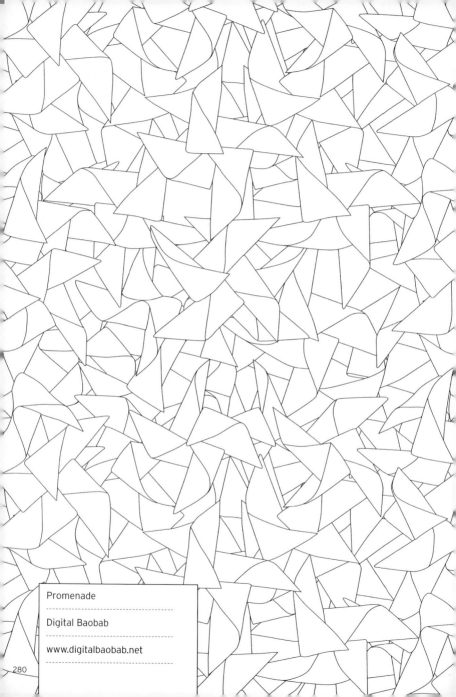

Promenade

Digital Baobab

www.digitalbaobab.net

Nocturnal

Beci Orpin

www.beciorpin.com

Windmill

Erica Wakerly

www.printpattern.com

White Room

Tracy Kendall

www.tracykendall.com

Monsters

Jan Avendano

jarnmang.blogspot.com

Horse

Mocchi Mocchi

www.mocchimocchi.com

Peony

Helen Amy Murray

www.helenamymurray.com

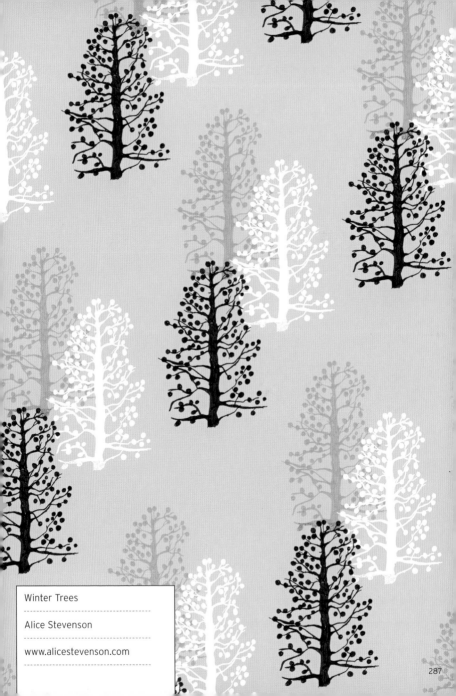

Winter Trees

Alice Stevenson

www.alicestevenson.com

Elbac

Anne Kyyrö Quinn

www.annekyyroquinn.com

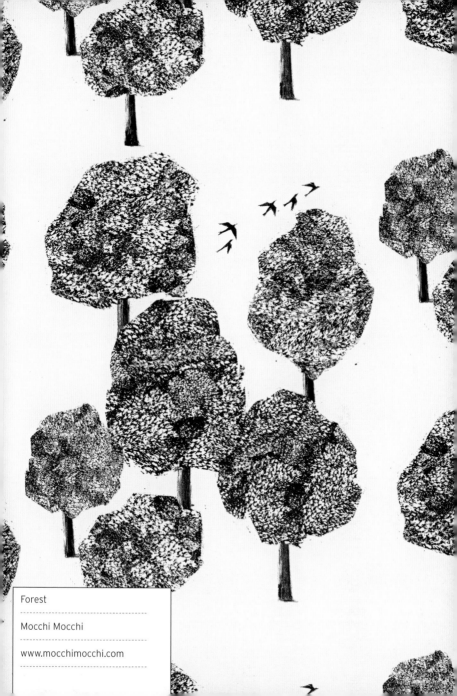

Forest

Mocchi Mocchi

www.mocchimocchi.com

Askar 2

Ellen Berggren

www.ellenberggren.se

Winter

Alice Stevenson

www.alicestevenson.com

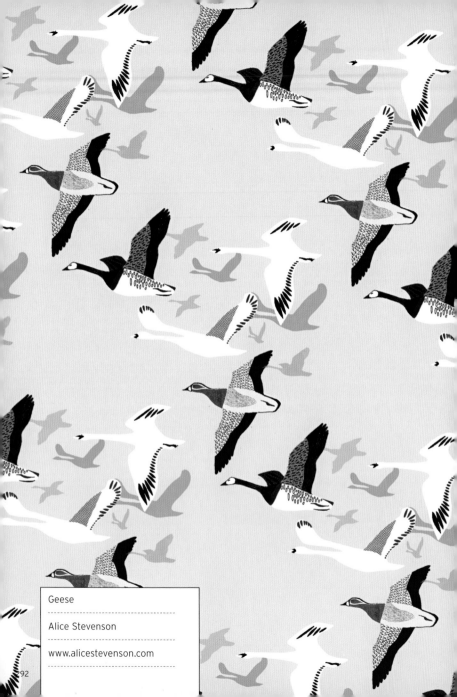

Geese

Alice Stevenson

www.alicestevenson.com

Jungle

Helen Amy Murray

www.helenamymurray.com

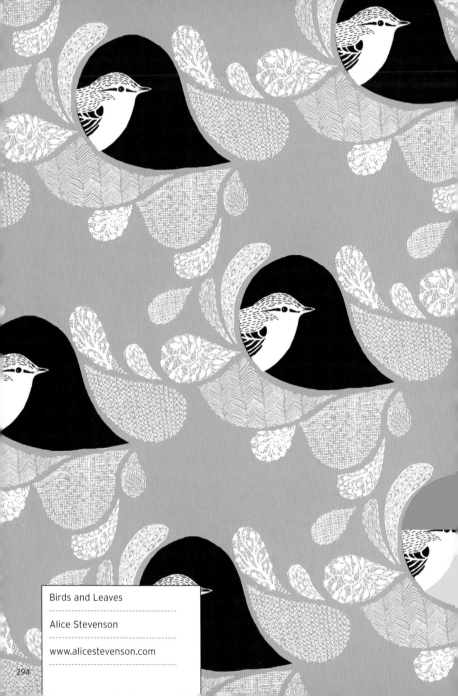

Birds and Leaves

Alice Stevenson

www.alicestevenson.com

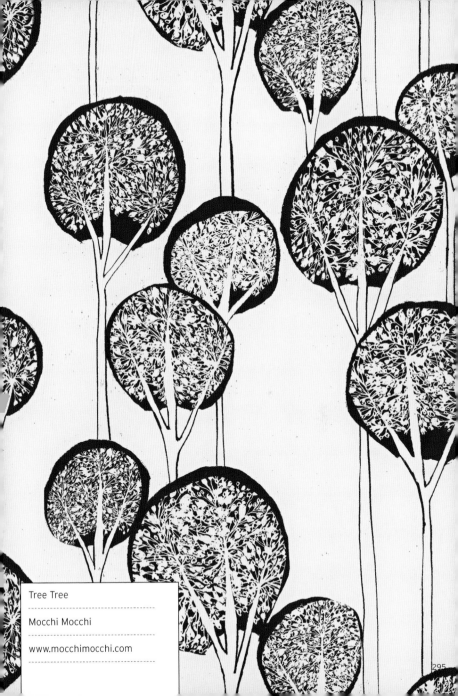

Tree Tree

Mocchi Mocchi

www.mocchimocchi.com

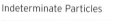

Indeterminate Particles

Reed Danziger

www.reeddanziger.com

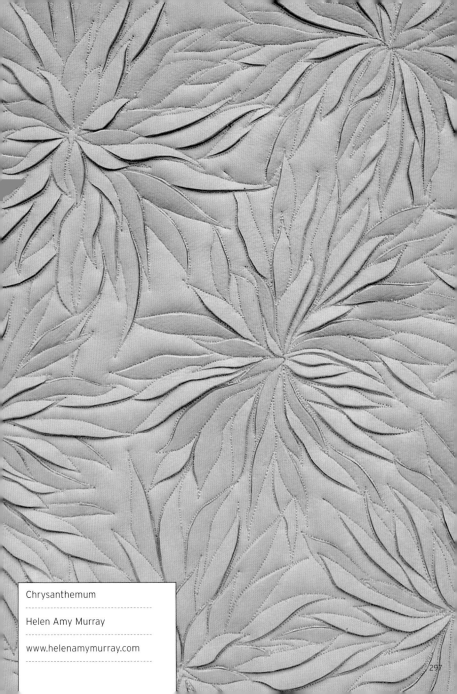

Chrysanthemum

Helen Amy Murray

www.helenamymurray.com

Bird and Pear

Alice Stevenson

www.alicestevenson.com

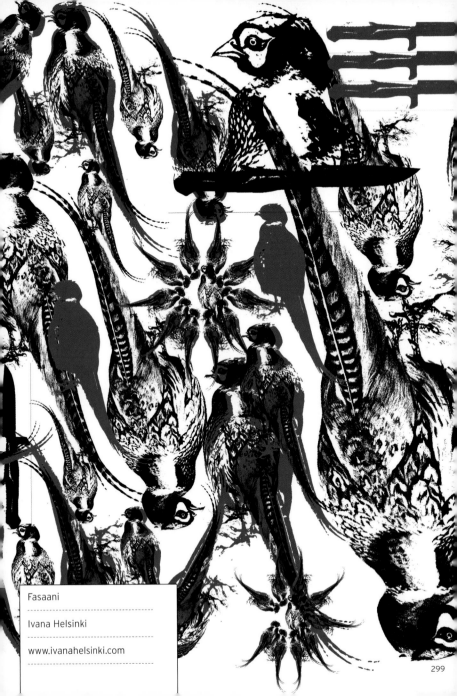

Fasaani

Ivana Helsinki

www.ivanahelsinki.com

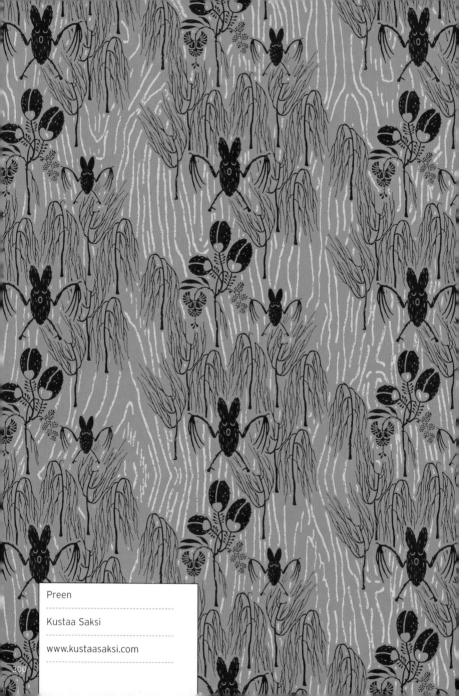

Preen

Kustaa Saksi

www.kustaasaksi.com

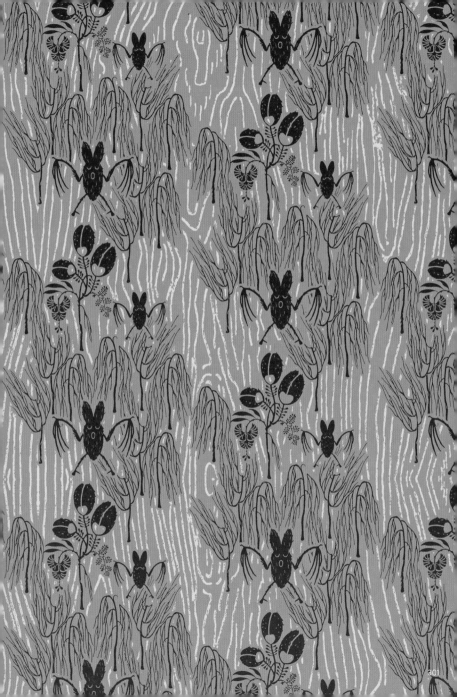

Temptation

Brit Hammer

www.brithammer.com

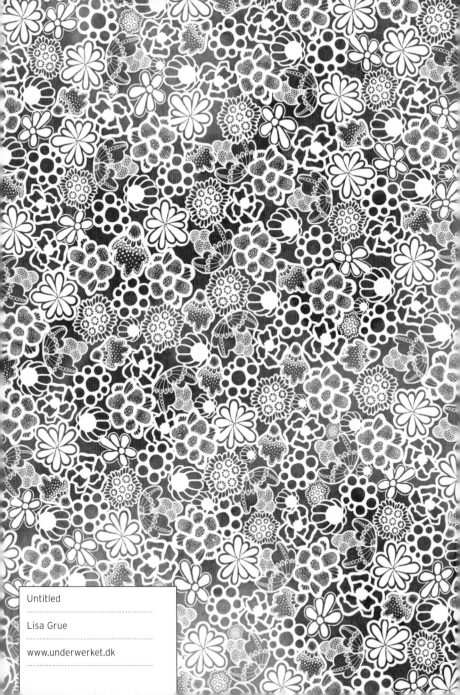

Untitled

Lisa Grue

www.underwerket.dk

Good Bye Nail Fungus

Mark Dean Veca

www.markdeanveca.com

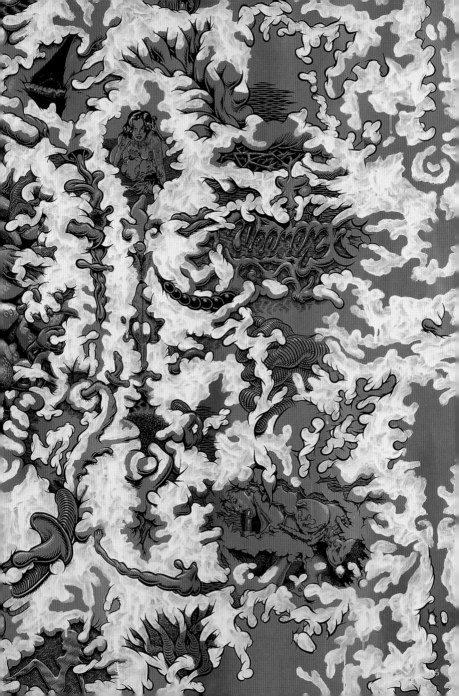

Adam Hayes

www.mrahayes.co.uk

This young illustrator, designer, and art director was born in 1981 in Stoke-on-Trent, England. twenty-five years later, he graduated from the Royal College of Art and started his own studio, where he began creating projects for himself, his friends, and clients from all over the world. This last group includes such renowned names as the style and fashion magazine *Dazed and Confused*, the American newspaper the *New York Times*, publishing house and distributor John Brown Citrus Publishing, Goodby Silverstein & Partners Advertising, *Grafik*, Howies, the Royal College of Art, and Sony.

Aimée Wilder

www.aimeewilder.com

A 2001 graduate of The Art Institute of Chicago, Aimée Wilder is a textile and graphic designer. Born in 1979 in New York, she continues to live and work there. Amongst her list of clients rank names like *Martha Stewart Living* magazine, Urban Outfitters, Dwellbaby, Designspace, Dwell, and Skip Hop. Along with her freelance work for all manner of clients, Aimée designs her own products. Among her influences, Aimée cites contemporary art and graphic design, logo design, typography, illustration, toys, and rock posters.

Alex Lin

www.alexlin.org

Alex Lin is a graphic designer. Educated at Yale University and the University of the Arts, he is currently living in New York and working with designer Anisa Suthayalai. Previously, he worked in the multidisciplinary studio 2x4 and served as lead environmental graphics designer of the Illinois Institute of Technology and at the Glass Pavilion at the Toledo Museum of Art. His work has been shown at the Cooper Hewitt Museum of Design and internationally recognized by a multitude of institutions. In 2006, he won the Art Director's Club Young Guns 5 prize.

Alice Stevenson

www.alicestevenson.com

Having graduated with a degree in illustration from Brighton University in 2005, British illustrator and textile designer Alice Stevenson is currently working freelance for such clients as the publishing houses Faber and Faber, Transworld Publishers, and Puffin, the *Time Out* guide, the *Saturday Telegraph Magazine*, and the *Guardian* newspaper. Influenced by illustration and the textile and graphic design of the 50s, Alice's work plays with organic shapes inspired by nature, which is where this artist finds a great deal of her inspiration.

Andreas Samuelsson

www.andreassamuelsson.com

Swedish designer Andreas Samuelsson (Linköping, Sweden, 1978) studied graphic design at the Berghs School of Communication at Stockholm. He's worked for American clients, as well as others from Canada, Germany, and Sweden. Some of these are *Dagens Nyheter*, *Odd Magazine*, *Odd at Large*, *Gringo*, *Tidningen Macho*, *The Crier*, and *Walrus Magazine*. Andreas tends to draw various elements and gather them together into a group. This achieves the effect that all the smaller pieces become part of a larger collage. His inspirations are drawn from musical and cinematic memories, videogames, and the people he has known.

Anne Kyyrö Quinn

www.annekyyroquinn.com

Textiles cut, sewn, and finished by hand. Rich textures, attractive designs and daring colors designed to harmonize with any interior. These are the creations of Anne Kyyrö Quinn; her fabrics are devised to become three-dimensional structures and stand apart from traditional flat ornamentation. Basing her work on organic shapes, she expresses Scandinavian simplicity on cushions and tablecloths. Anne is one of the principle manufacturers of handmade textiles in Great Britain. Her studio, established in London in 1999, makes her products to order and distributes them internationally.

Atelier LZC

www.atelierlzc.fr

Vanessa Lambert, Barbara Zorn, and Michaël Cailloux graduated from the École Supérieure des Arts Appliqués Duperré of París. In 2001, the three partners founded the design studio Atelier LZC. Here they create textile designs, illustration, designer items, and fashion design. They produce exclusive collections that include crafts, interior decoration, fabrics, and illustrations for some of the most important fashion and interior design companies in the world. Some of the clients that have bet on Atelier LZC are Habitat, Cartier, Dupont, Van Cleef & Arpels, Ikea, Galeries Lafayette, *Elle Deco Japan*, and Art Sticker.

Bantie

www.bantie.se

Bantie, founded by Ulrika Gyllstad and Wilhelmina Wiese, is a young textiles company based in Stockholm which produces designs and fabrics for interiors. Ulrika is a designer trained in the fashion industry. Wilhelmina has acted as an accounts director for various communications consulting agencies. Tired of the impersonal fashions characteristic of mass production and armed with the desire to design fun and stylish fabrics, together they created Bantie. The company's name pays homage to Ulrika's favorite aunt, owner of a store that sold exquisite fabrics and exclusive linens. All of the textiles made by Bantie are produced in Sweden.

Beci Orpin

www.beciorpin.com

Beci Orpin, a prolific artist and designer out of Melbourne, is behind the Princess Tina brand. Her work is based on folk narrative. Its particular universe is comprised of an amalgam of influences: designer names like Alexander Girard, Robin Boyd, or Richard Neutra; traditional Bulgarian embroideries; Chinese slippers; homemade sponge cakes or *chiyogami* (a type of Japanese paper decorated with bright colors and lovely details). Any source of inspiration can become an iconic graphic, like Sad Tooth, a character created by Beci that may be found in some of her prints.

Brit Hammer

www.brithammer.com

Human relations, spirituality, the earth, and the beyond are what inspire the work of Norwegian-American artist Brit Hammer. Brit, who inaugurated her own gallery in 2006, works with hand-made Murano glass and uses the reflection of light to create architectural installations and crafts. Lighting plays an integral role in her work: her pieces invite the viewer to interact with them by walking back and forth to capture the sparkles emanating from within. The various angles from which light is reflected convert her pieces into as many works of art as there are times of day or seasons in the year.

Carly Margolis

www.cavernhome.com

Cavern is a collection of colorful, silk-screened wallpaper designs by Carly Margolis. Although this twenty-four-year-old New York artist and designer draws her inspiration from nature, her collection cannot be categorized into any particular genre. One of her most popular prints is Paleolith, which evokes the world of archaeological excavations. Its sinuous lines remind one of the temporal strata lines formed by sediment and rock, ocean currents, glacial cracks, and the wind's path. Indigenous North American cultures also figure into these imaginary visuals.

Catalina Estrada

www.catalinaestrada.com

Columbian designer Catalina Estrada has lived and worked in Barcelona, Spain, since 1999. Her work unites the colors typical of Latin American folklore with the sophistication of European graphic design. Magical worlds of baroque colors, fantastic characters, and nature's elements form the foundation of her work. She has received recognition from, amongst others, the magazine *Computer Arts*. Her work has appeared in magazines like *Swindle* and *Paper and Graphic*. Among her clients we may find such names as Paul Smith, Coca-Cola, Nike, Honda, and Custo-Barcelona, among others.

Catriel Martínez

www.catnez.com.ar

Catriel Martínez is an Argentinian designer born in Gualeguaychú, in the province of Entre Ríos. His field of work extends to graphic design and illustration. Defined by many art critics and admirers as "a marvelous talent," he imbibes his capricious drawings with a certain infantile quality. These possess the same sophisticated mix of playful and contradictory spirit he infuses in all his work. His style is natural and relaxed. Catriel further investigates the intelligent use of different materials, thus easily classifying his work as experimental.

Chisato Shinya

www.kin-pro.com

This Japanese illustrator, originally from Sapporo, goes by the artistic name of Kin Pro. Her prints, inspired by pop culture and nature itself, have appeared in an endless list of magazines, television commercials, books, and expositions. In 2003, her fame became widespread thanks to *Grimm*, a contemporary version of the Brothers Grimm fairy tale that she illustrated. Chisato creates contrasts within the motifs she uses, all the while imagining that the creative lines she produces will ultimately find their way into a child's bedroom. Her goal is to create spaces that make people happy.

Cloth Fabric

www.clothfabric.com

Designer Julie Paterson is the owner of Cloth Fabric, a small, independent Australian company that also employs four other people. Cloth Fabric has been designing and manufacturing handmade textile prints since 1995. Julie designs all of her prints in her Sydney workshop, inspired by the countryside that surrounds her there. A good part of these designs become definitive patterns and end up printed on fabric. Cloth Fabric performs as successfully as a small-scale producer as it does on larger scales, usually orders placed by architects or interior designers.

David Monsen

www.davidmonsen.com

The young Swedish designer David Monsen is a 2007 graduate of Gothenburg University's School of Design and Craft. Recently, he moved to Stockholm, where he established his center of operations. Monsen mostly works with patterns, though he is also an illustrator and graphic designer. Much of his work is based on his daily experiences. He almost always works with two dimensions, though sometimes he likes to create his illustrations as if they were three-dimensional objects, an integral part of some room, or in combination with other elements.

Deuce Design

www.deucedesign.com.au

Bruce Slorach and Sophie Tatlow founded their Deuce Design studio in 1999, specializing in graphic design, branding, and inter-disciplinary projects. The Powerhouse Museum in Sydney, the Australian real-estate company Carrington, and the MoodTV channel are some of their clients. Their famous work for the Central Hotel was widely reviewed in magazines like *Frame* and *Inside*. Deuce Design does work in practically every aspect of graphic design (Internet, textiles, wallpaper, etc.), frequently collaborating with architects, interior designers, and landscapers, depending on the orders they've received.

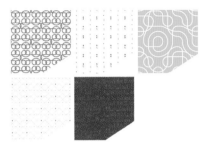

Digital Baobab

www.digitalbaobab.net

Claire Moreux and Olivier Huz, born in 1977 and 1976 respectively, met each other at the École des Arts Décoratifs of Strasbourg in 1998. Since then, they've created many CD covers for Aspic Records. In Lyon they found their first contract with the La Salle de Bains Center for Contemporary Art. Later, they began working as independent graphic designers for some important institutions, like the Palais de Tokio and Frac Aquitaine, Les Presses du Réel publishing house, and a few international artists like Jeppe Hein and Swetlana Heger. They also design books, posters, and art pieces.

Eleanor Grosch

www.pushmepullyoudesign.com

In 2003, Eleanor Grosch created her Pushmepullyou Design studio in Philadelphia. Its name pays homage to Dr. Doolittle's two-headed llama. Although her initial work consisted of creating silk-screens and posters, she is now designing all types of applications. After graduating from the University of South Florida, Grosch worked as a freelancer in Philadelphia. As an illustrator she works for Alien Workshop, where she has learned to simplify her lines. She has declared herself an enthusiast for the design work of Dirk Fowler and Sanna Annuka, among others. Grosch makes all her prints by hand using high quality, softly-toned paper.

Eley Kishimoto

www.eleykishimoto.com

Mark Eley and Wakako Kishimoto, internationally known as Eley Kishimoto, started off in textile design. In the 90s, they entered the world of fashion by launching their first collection for women. But it is their prints which have earned them their reputation and started a following on the international design scene. Because of this, these two designers, one Japanese and the other Scottish, continue to work in textile design as well as interiors and architecture. Among their clients and collaborators are Habitat, Motorola, Architectural Foundation, Shiseido, Marc Jacobs, Louis Vuitton, and Hussein Chalayan.

Elisabeth Dunker

www.lula.se

Swedish designer Elisabeth Dunker graduated from Gothenburg University's School of Design and Craft in 2006. For the last two years she has been working principally in graphic design, illustration, and drawing patterns for children's products, like upholsteries, textiles, posters, and duvets. She is also a photographer and stylist working for different Swedish magazines. Based in Gothenburg, she is the founder of the Lula Design Studio. Amongst her clients may be found Mairo, La Shelf, Dangerous Goods, Manolo Santana, Dansbyrån, Kasper, *Petit magazine*, *Mama magazine*, and *People*.

Ellen Berggren

www.ellenberggren.se

Born in Pitea, a small city in northern Sweden, this illustrator has specialized in illustration and pattern making. Ellen Berggren graduated from Gothenburg University's School of Design and Craft. At present, she lives and works in the same city where she studied. Her patterns create a three-dimensional optical illusion through the use of all kinds of intertwined figures, including those which are organic, geometric, or abstract. Disquieting figures and strange urban landscapes populate her illustrations.

Emil Kozak

www.emilkozak.com

Inspired by his passion for the skateboard, Danish designer Emil Kozak decided to dedicate himself to graphic design. This is a path that other contemporary graphic designers have traversed before, but in Kozak's case it has led to a very fresh and positive personal style. His trademark is the use of clean lines and typography, not to mention a certain desire to reduce the use of color to a minimum. His work has been widely shown in the United States and Europe, aside from having appeared in various international graphic design magazines. Amongst his clients are names like Vans and Eastpak.

Erica Wakerly

www.printpattern.com

Erica Wakerly, a 2005 graduate of the Royal College of Art in London, has been designing and commercializing her own wallpaper and textile products for two years. Occasionally, she works as a freelance graphic designer on architectural projects. Her body of work moves between two poles: her past as an illustrator and her characteristic geometric designs. Erica won first prize in a wallpaper contest organized by RCA, and was amongst the candidates for the 2006 Blueprint prize for best newcomer awarded at the 100% Design event.

Esther Hong

www.jinizm.com

Most people write love letters in school. Esther Hong *designed* them. These meticulously designed love letters denoted her passion for graphic design just as much as, in her own words, "the lifestyle of San Francisco". Esther Hong's work can be seen on HP computers, colored paper from Naked and Angry, or bags from the SkipHop label. Her work has received recognition from the American Design Awards and magazines like *Print* and *How Design*, among others. Since 2007, Esther has been working as an independent freelance designer.

Estudio Mopa

www.estudiomopa.com

Mopa, a graphic design and illustration studio created in 2006 in Brazil, is made up of the designers Alline Luz, Daniel Gizo, Felipe Mello, Felipe Medeiros, and Rogério Lionzo. Unlike what usually happens in other graphic design studios, Mopa grants each member complete creative liberty. This stylistic eclecticism is what allows them to adapt to all manner of projects and clients. Mopa accents the social aspects of their work, which they develop, in their own words, "in a humanist fashion." Their motto? "We love you, please love us back."

Eugène van Veldhover

www.dutchtextiledesign.com

Dutch designer Eugène van Veldhover, born in 1964, was educated in fashion design at the Willem de Kooning Academy of Art and Architecture in Rotterdam in 1993. He first began by working as a fashion designer at Marithé & François Girbaud. Since 1996, he's been a textile designer. His specialty is the combination of printing techniques, like laser-cutting, silicone layering, reliefs, and ultrasonic welding. His industrial prototypes have been exhibited at textile fairs like Heimtextil and Decosit. Eugène is a professor at the Department of Textiles and Fashion at the Royal College of Arts in La Haya.

Extratapete

www.extratapete.de

Extratapete is a Berlin-based company that specializes in the design and manufacturing of original and daring wallpaper. Souvenirs, trips, experiences, smells, and all that forms part of individual memory or the realm of sensory experience are what serve as inspiration for the varied wallpapers they create. One of their products, for example, reproduces a map of an island with different cartographic elements, all from a perspective that understands that 70 percent of the earth's surface is covered in water. Any stratum in the realm of memory or dream may be converted into a motif to adorn their wallpaper.

Galina

mari-art-i.livejournal.com

Galina Panchenko, a Ukrainian freelance illustrator licensed in 2003 by the National University of Construction and Architecture at Kiev, says she: a) hates being lied to, having to wash dishes, and spilling Indian ink all over her drawing table, b) remembers that, when she was young, she tended to answer "a mother" to the question "what do you want to be when you grow up?", c) dislikes eating alone, d) can't stand it when people look over her shoulder while she's drawing and when people ask her what her drawings are trying to say, and e) loves the sea, fall, her niece, free time, sleeping a lot, and sneak peeks.

Geka Heinke

www.gekaheinke.de

German illustrator Geka Heinke was born in 1967 in Ludwigshafen, Germany. At present, she is living and working in Berlin. Her body of work, which has been shown during the last five years in cities like Berlin, Detroit, Munich, Mannheim, and Dublin, is the result of an accumulation of graphic elements that reveal hidden aspects of everyday life while empowering apparently neutral objects with transcendental significance. In this sense, it has been frequently said that Geka's work is like "a veil that hides something from the spectator and prevents one from seeing the exterior" (much like a curtain would do).

Hannah Stouffer

www.grandarray.com

Colorado and the city of San Francisco are the two poles between which American illustrator Hannah Stouffer's work finds its home. The contrast of decadence and luxury on one side and the imagery we unconsciously associate with nature's wild on the other is the distinctive signature of her designs. Among Stouffer's clients can be found names like Sony, Disney, Coca-Cola, IBM, Dell, MSN, Camel, the magazines *Soma* and *Subtle*, and fashion labels like Drift and Brodeo. Her work has been shown during the past four years in galleries in Houston, San Francisco, and Phoenix.

Hanna Werning

www.byhanna.com

Swedish designer Hanna Werning graduated with a degree in graphic design from Central St. Martins College of Art & Design in London, although, recently, she has amplified her field of work to include the design of wallpaper and textiles. In the summer of 2004, after living in London for six years, Hanna decided to return to Sweden and establish herself definitively in Stockholm, where she founded her own studio. In 2006, she launched her first collection of wallpaper rolls in collaboration with the Swedish brand Boråstapeter. Other clients of hers are Ikea, the Wisconsin Film Festival, Eastpak, and fashion labels like Boxfresh, Stüssy, and Dagmar.

Helen Amy Murray

www.helenamymurray.com

Helen Amy Murray, a textile designer living in London, enjoys international recognition thanks to her luxurious handmade creations inspired by nature itself and her particular application of relief on fabric. Upon graduating from the Chelsea College of Art in 2002, she launched her namesake label one year later. She has created many notable projects for design companies while completing made-to-order items for private clients as well. She combines design, color, and materials into different applications that range from interior pieces to decoration.

Hello Hello

www.hellohello.name

Stephen Crowhurst is the artist, art director, illustrator, and designer behind Hello Hello. Son of Swedish and Polish immigrants, he's been working freelance in Toronto, Canada, which is where he was born in 1973, for the last eight years. Crowhurst's work touches upon themes like beauty and nature, and his creative methods mix handmade processes with some of contemporary design's most modern technologies. His appearance in international publications like *Zoo*, *Creative Base*, *Butter*, *Composite*, and *Rojo* have taken him beyond a merely Canadian creative sphere.

Hello Monday

www.hellomonday.net

Hello Monday is a young design agency from Aarhus, Denmark, that in recent years has won deserved fame on the international design scene. This has led them to appear in dozens of specialized publications and receive requests from a disparate array of clients. Winners of the FWA (Favourite Website Awards) for their webpage design and programming for fashion label Minus, the members of Hello Monday say they prefer to work "on all that which has to do with creativity in every form."

Henrik Vibskov

www.henrikvibskov.com

Henrik Vibskov works in the realm of visual art, music and fashion. Though born and currently working in Denmark, he graduated from Central St. Martins in London. Style and fashion magazines like *The Face*, *Dazed and Confused*, *i-D*, *Wallpaper*, and *Vogue* have published his creations. His work has been exhibited in Tokyo, London, New York, Paris, Copenhagen, and Berlin. His brand, Henrik Vibskov, is only sold in exclusive stores. Giving true meaning to the concept of the multi-disciplinary artist, Henrik also makes short films and documentaries and takes part in various independent music projects.

Hvass & Hannibal

www.hvasshannibal.dk

Hvass & Hannibal is a creative cell based out of Copenhagen and founded by designers Nan Na Hvass and Sofie Hannibal. At present, both are studying at the Danmarks Designskole. This has, nevertheless, not impeded them from meeting dozens of orders ranging from CD covers (mostly for the Danish label Rumraket), illustrations, silk screens, styling, photography, murals, and posters. In 2006, they painted a 54-square-foot mural in Copenhagen's Vega Club, and it is anticipated that they will perform a similar feat at the Forma Nova Festival. Hvass & Hannibal share a studio with their friends Bottega Areté.

Idiot Copenhagen

www.idiot-copenhagen.com

Kasper Ledet is a young Danish artist, graphic designer, and illustrator who lives and works in Copenhagen. His style comes from varied influences: anatomy, plants, symbols of daily routine, and abstract systems. Some of his patterns find inspiration in the visual language and local traditions of other cultures; others superimpose two distinct motifs, resulting in a uniquely strange optical stimulus. To liven up his creations without any limitations, he uses digital tools as well as more traditional ones.

Ivana Helsinki

www.ivanahelsinki.com

Finnish designer Paola Suhonen is immediately recognizable in the eyes of an expert public for her "innocent-girl-with-a-rocker-attitude" style; also, she's the founder of the Ivana Helsinki label and one of the hip names on the Finnish design scene. Paola erases the lines between art, fashion, and design with sophistication and the latest styles that have helped popularize the Fennofolk movement in her country's communications field by imposing experimentation upon traditional Scandinavian esthetics. Ivana Helsinki's collections are sold in over twenty countries.

Jan Avendano

jarnmang.blogspot.com

Jan Avendano is a graphic designer who lives and works in Toronto. Through the use of hand-drawn lines and shapes, Jan achieves fun and original designs. Her interests cover designing shirts, patterns, book and CD covers, and graffiti, and using random scrawlings as creative tools. She sells her creations herself, printed on shirts or on her blog, where she periodically publishes illustrations, which usually depict a wide variety of monsters.

Jeffrey Fulvimari

www.jeffreyfulvimari.com

Jeffrey Fulvimari was born in Ohio but developed his artistic talent in New York. He started his career as an illustrator for Barney's New York and *Interview* magazine. His illustrations have made their way to MTV, VH1, Nickelodeon, The Food Network, and numerous Japanese commercials. His fame in that country is owed to a 1998 exhibition of his work at the Parco Gallery in Tokyo. Since then he has published two monographs, *It's OK And Everything's Gonna Be Alright* and *Jeffrey Fulvimari's Greatest Hits*. Presently, he is living in the woods in a house by a lake in the state of New York .

Jennie Olsson

www.mermermer.com

Jennie Olsson is an industrial and textile designer living in Sweden. She graduated from the prestigious HDK, Gothenburg University's School of Design and Craft, in 2004. Since then, she has basically been working as a freelance designer, dedicating the majority of her time to creating pattern designs, a talent for which she has been widely recognized in publications of international influence. Jennie belongs to Mermermer a design collective located in Gothenburg, where other members include such artists and designers as Camilla Blomgren, Frida Sjöstam, Lotta Kvist, and Karin Persson.

Jenny Wilkinson

www.jennywilkinson.com

Jenny Wilkinson is an independent British designer who created her own studio in 2003. She studied 3D design at Brighton University. Her works include wallpaper and textile design, as well as designing surfaces in wood, metal, ceramic, and plastic. Jenny's most popular work is Wallpapers-By-Numbers, a true innovation in wallpaper, already considered a classic—it is designed to be colored with colored pencils or markers. Launched in 2003 with the Tilly print, the line has not only continued to grow, but also has been acquired by the Victoria and Albert Museum as well.

Jessica Romberg

www.stockholmillustration.com

Swedish designer Jessica Romberg studied between 1994 and 1997 in the fashion department of the Beckman School of Design in Stockholm. She started in this sector with her own brand of street clothes, YoYogi, elaborating upon her own illustrations when she couldn't afford a photographer. Illustrations have increasingly made up the majority of her output, and since 2002 she has been working exclusively as an illustrator. While she lived in Japan, between 2003 and 2004, she created numerous graphic patterns. Her pattern in this book belongs to that period.

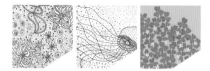

Jill Bliss

www.jillbliss.com

Jill Bliss was born and raised on her family's Northern California farm. On that farm, everything from the food to the house itself, the machinery and even the home computers, were made by hand by members of the family. After graduating with a degree in design at from Parsons School of Design in New York, Jill started working as a fashion designer and illustrator. Her work, which most of the time includes drawing her own pieces as well as sewing them by hand, is inspired by the techniques of traditional handicrafts.

Julia Pelletier

www.juliapelletier.com

After graduating with a degree in textile design and print-making from Central St. Martins of London, Julia Pelletier arrived in Barcelona in 2000 in search of something new. The result? Prints made for other designers and for her own brand, ¿Quépasajulia?; the inclusion of her ornamental textiles in exhibitions; and the publication of her illustrations in various Spanish magazines. She is a member of the Comité, a multidisciplinary creative center that commercializes its own collections. Her goal is to transform cloth and paper into small frames full of motifs, textures, and colors: spaces full of life that cover the body and its surroundings.

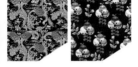

Klaus Haapaniemi

www.klaush.com

At a very young age, the Finnish artist and designer Klaus Haapaniemi became interested in illustration while watching the Russian and Czechoslovakian cartoons that were aired on Finnish television. Today, Klaus is an important and admired contemporary illustrator. He creates his own esthetic, influenced by pattern designs, children's art, and ink sketches. WGSN's analytical survey of tendencies has proclaimed him an up and coming star in the modern world of illustration and design. He lives and works in East London.

Koldbrand

www.koldbrand.com

Koldbrand, or Søren Nørgaard (Denmark, 1973), has been drawing and painting all his life. In elementary school he was already coloring the illustrations in his textbooks. Years later, he opted for graffiti and underground music instead. A pop art enthusiast, he opted for a career as a graphic designer, specializing in typography. Today, Koldbrand is a multi-talented artist who paints, draws, and works on installations and sculptures. Koldbrand is living in Copenhagen, where he earns a living as a senior art director. He has won awards for best Web design at the New York Festival.

Kustaa Saksi

www.kustaasaksi.com

The Finnish Kustaa Saksi is one of the most well-known and admired contemporary illustrators around today. His unique body of work, which unites psychedelia, baroque, and fantasy-like colors, organic elements, and sinuous shapes, has been published in mediums as diverse as *Playboy*, *Sleazenation*, and *Wallpaper*. Barely twenty-nine years old, Kustaa has expanded his field of work to include publicity and audio-visual projects. Havaianas, Issey Miyake, Vespa, Mercedes-Benz, and the magazines *Flaunt* and *Nylon* are some of his clients. Presently, he is living in Paris, a city he terms "disappointing."

Lara Cameron

www.laracameron.com

Living and working in Melbourne, Australia, Lara Cameron began her career as a freelance graphic designer. Recently, she has launched herself into the world of textile design, where she designs and produces a wide array of handmade silk textiles that she sells on the Web at http://kirinco.etsy.com. Lara is fascinated by the wide scope of possibilities available when designing patterns. Designing her own patterns allows her to distance herself from the rigidity of work orders. "I like to design patterns for myself. It's a healthy way to relax in contrast with my more conventional work."

Lene Toni Kjeld

www.walldecoration.dk

Thirty-one-year-old Danish designer Lele Toni Kjed has created a wallpaper collection comprised of eight different designs. Four of these are hybrids, which become very useful when one wants to divide a room into smaller areas. The idea is to create innovative interiors with a mixture of styles and patterns that enable you to decorate your home in non-standardized fashions. The patterns contain complex details, which contrast well with minimalist interiors. For Lene, designing wallpaper became a challenge: "on a wall, every detail is exposed to being held under consideration."

Lina Bodén

agnesmarialina@gmail.com

Lina Bodén is an illustrator who lives and works in Stockholm, Sweden, and studies publicity and graphic design at Beckman's Design College. Previously, she studied painting at the Idun Lovén and Gerlesborg art schools. For her work, she tends to find inspiration in her own memories, dreams, and the stories her friends have told her. Her trademark style, detailed and elegant, with barely any note of color between black and white, makes her one of the more exciting prospects in Scandinavian illustration.

Lisa Grue

www.underwerket.dk

Lisa Grue graduated from Danmarks Designskole in 2001. A year later she founded the creative platform Underwerket, from which she produces her work as an illustrator and graphic designer. Her unique style comes from an equal mix of outlandish ideas, irony, and a poetic femininity. Recently, she was recognized as a promising newcomer in Danish design, garnering her a grant from the National Art Foundation of Denmark. Her fountain of inspiration is drawn from urban life, literature, music, the arts, and above all, the trips she has taken. On these trips she compiles photographs, stickers, and figurines that she will later use in her creations.

Lisa Jones

www.lisajonescards.com

Designer Lisa Jones has been working with her partner, Edward Underwood, since 2000. Together they design, produce, and print greeting cards, for which they use some hardly conventional graphic elements, giving their cards a marked personality. Many of these cards have been printed on both sides, others have roving eyes... Lisa recognizes some of her influences to be ceramics from the 70s, illustration from the 50s, and Scandinavian folklore. Lisa also does freelance work; Inspired Recycling commissioned her Woodblock project for the 2005 London Design Week.

Lotta Kühlhorn

www.lottakuhlhorn.se

Swedish illustrator and graphic designer Lotta Kühlhorn studied at Konstfack University College of Arts, Crafts and Design, where she graduated in 1987. Since then, Lotta has worked as an illustrator for all kinds of magazines and has created graphic patterns for products as diverse as plates, cutting pads, and glazed tiles. Nevertheless, most of her time is dedicated to designing books, a task which allows her to combine her interest in graphic patterns, color, and typography. Her clients include Ikea and Pocketshop.

Maja Sten

www.majasten.se

Designer Maja Sten studied graphic design and illustration at the Konstfack University College of Arts and Crafts in Stockholm. She is currently a tutor there, a job she also performs at both Beckmans College of Design and the Berghs School of Communication in Stockholm. Since graduating in 2002 with a degree in art and design from the Royal College of Art, Maja Sten has been working as an illustrator, visual artist, and editorial illustrator. Now she runs her own company in Stockholm, White Mountains. Her work has been exhibited at galleries in London, Tokyo, and Stockholm. Amongst her clients are Anna Sui and Stüssy.

Malota

www.malotaprojects.com

Malota is a twenty-seven-year-old Spanish illustrator and graphic designer. She was born in Jaén, where she took classes in drawing, painting, and music. At the age of eighteen, Malota moved to Valencia. She continued her education at the school of Bellas Artes San Carlos. After graduating, Malota worked at a communications and publicity studio for over three years, first working on layouts and design then moving on to take charge of project coordination as an art director.

Marcel Wanders

www.marcelwanders.com

Marcel Wanders was born in 1963 in Boxtel, Holland, graduating cum laude from the School of the Arts in Arnhem in 1988. Marcel's fame began with his iconic Knotted Chair, which he produced for Droog Design in 1996. Today, Marcel designs for large European firms like B&B Italia, Bisazza, and Moooi, where he is director and co-owner. Many of his designs have been selected for some of the most important design collections in the world, such as MOMA and the Danish Museum of Art and Design in Copenhagen. He has appeared in important design publications like *Frame*, *Wallpaper*, and *Esquire*.

Marcus James

www.marcusjames.co.uk

Marcus James grew up in British West Country, graduating with a degree in illustration from Central St. Martins in London. At the Royal College of Art, he did a masters degree in the same. Since then, Marcus has worked as a freelance illustrator and pattern designer. He has collaborated on designing rugs and cloth printing for Chloe, Yves Saint Laurent, and Levi's. He's worked on publicity campaigns, album covers, for restaurants, as well for expositions, magazines, and books. Some of his clients are Nike, Virgin Records, Output Records, and *Dazed and Confused*.

Mark Dean Veca

www.markdeanveca.com

Mark Dean Veca was born in 1963 in Shreveport, Louisiana. He graduated from the Otis Art Institute in 1985. His work, mostly paintings, drawings, and art installations, has been seen in galleries and museums across America, Europe, and Japan. Among them are PS1/MOMA, the Drawing Center, the Brooklyn Museum, the Bloomberg Space, and the Yerba Buena Center for the Arts. Mediums like the *New York Times*, *Juxtapoz*, *Artforum*, *Art in America*, and *Flash Art* have published reviews and articles of his work. Today, Mark lives and works in Brooklyn, New York.

Me Company

www.mecompany.com

Paul White founded the design studio Me Company in 1985. He chose this name as an umbrella under which he could house the many pseudonyms he's used to sign his designs, allowing him to exercise different creative personalities. The company grew and, little by little, integrated an elite group of digital artists. Me Company has specialized in the fields of composition, animation, and digital sculpture. The images they create are impactful, their inspiration born of the shared passions of the group's members: modernity, technology, art, and fashion.

Metrofarm

www.metrofarm.net

The Berlin studio Metrofarm is run by Julia and Nunu, and their work includes creating design concepts, creative consulting, commissioning expositions, and production. Their clients include Absolut Vodka, Nike, 55dsl, and Pioneer. Working with the latest generation software, they create patterns with randomly mixed drawings, while making furniture pieces by hand. One of their most popular patterns is their celebrity series, where the faces themselves serve as a motif to be repeatedly printed throughout.

Mike Perry

www.midwestisbest.com

From his small studio in Brooklyn, New York, Mike Perry designs, illustrates, creates typographies, and directs numerous artistic projects. He was a designer for Urban Outfitters for three years. Much of this prolific artist's work is handmade, characterized by a fresh and intentionally childish style. The Princeton Architectural Press was the publishing house behind the release of his first book, *Hand Job*, a 256-page compilation of his typography projects. His success, he says, is rooted in his "ability to make people smile."

Mina Wu

www.wretch.cc/blog/minawu

Designer Mina Wu (Ming-Lun Wu) was born on November 21, 1976, in Taipei, Taiwan. She is currently living and working in Amsterdam. Her path can only be described as "atypical:" after graduating with a degree in anthropology from the National Taiwan University in 1999, Mina moved to Amsterdam, where she studied jewelry-making at Gerrit Rietveld Academie. Afterward, she completed the IM Master at the Design Academy Eindhoven. Mina has received various awards throughout her career, among them the Gerrit Rietveld Prijs in 2004. Her work has appeared in publications like *Frame*, *Vogue*, and *Flair*.

Mocchi Mocchi

www.mocchimocchi.com

The Japanese studio Mocchi Mocchi designs, produces, and commercializes decoratively silk screened postcards on authentic Japanese paper by using traditional methods. Their rejection of industrial production processes is motivated by their conviction that traditional postcards have a warmth, durability, and quality far superior to conventional ones. Mocchi Mocchi is inspired by natural motifs, through which they attempt to express feelings, abstractions, and emotions like beauty, kindness, strength, etc.

MY.S

www.my-sss.com

The MY.S studio in San Pablo, Brazil, is made up of Maira Fukimoto, Yara Fukimoto, and Stephanie Marihan, three fashion and graphic designers. Their alliance began approximately ten years ago with nothing more than the desire to create together, in turn leading to the creation of MY.S. Their work, mainly illustrations, can be found at locations and on supports as varied as street walls, friends' apartments, restaurants and, of course, art galleries. They squander colors and create novel atmospheres that attempt nothing more than, in their words, "to make people laugh."

Nadia Sparham

www.nadiasparham.co.uk

Nadia Sparham was educated at the College of Communications at the University of the Arts in London. She's inspired by folk art and nature to make, by hand, the majority of her designs. Sparham rejects the notion of mass production. This preference for the artisan characterizes most of her pieces, printed just as often by hand as digitally, sewn together and bordered with silks, wool, and cottons. Many of her designs are made to order, guaranteeing uniquely original and personal products. Her work has been shown in the New Designers selection at London Design Week in 2006.

Naja Conrad-Hansen

www.meannorth.com

Born in Copenhagen, where she lives and works today, Naja Conrad-Hansen comes from a family of artists. She graduated from Danmarks Designskole in 2003, starting work as a freelance designer that same year. Her versatile trajectory covers many talents: illustration, painting, and graphic design. She also designs prints for different labels, including her own, Meannorth. Her work has appeared in fashion and design magazines like *Neon* and *Copenhagen Exclusive* and in books like *The Age of Feminine Drawing*.

Natsko

www.natsko.com

Natsko Seki is an illustrator and Japanese animator born in Tokyo but residing in London. After graduating from Brighton University in 2005, Natsko worked for clients like the *Guardian* and the *New York Times* newspapers. Natsko's work is inspired by the esthetics of the last century, primarily the decades between the 20s and 60s. Known for her graphic designs for the British publishing house Phaidon, Natsko says she works with the objective of creating "something positive, animated and fun." You may contact her through her agency, ZeegenRush (www.zeegen-rush.com).

Nice

www.niceness.co.uk

Matt and Sofie are the designers that make up Nice. Their work covers illustration, music, and designing fashion and objects like wallpaper, for instance. From their base of operations in London, they work for clients like the *Guardian*, Playstation, the Tate Modern Gallery, and Big Dada Recordings. Their wallpapers, some of which are hybrids, have received recognition in various mediums specializing in graphic and product design; notable amongst these is Domino, for which they used the motif of a never-ending row of dominoes.

No Pattern

www.nopattern.com

Chuck Anderson, a twenty-two-year-old Chicago artist, has been working under the name No Pattern since he was eighteen. Now, he counts among his clients such high-profile names as Warner Brothers, Nike, Absolut, Reebok, and Sony, aside from various artists in the music industry, like Fall Out Boy or Lupe Fiasco. Chuck tends to act as judge on fashion and design contests all over the United States. In September of 2005, he edited a monograph book covering his work as an artist, which is sold at his online store (www.npandco.com). On that webpage, Chuck sells his work and shirts with his designs and illustrations.

Paulina Reyes

www.paulinareyes.com

Paulina Reyes was born in Mexico City, where she studied industrial and graphic design. Upon graduating, she worked as a freelance illustrator in the fashion industry. Afterwards, she moved to Minneapolis, Minnesota, and worked as a designer for Laurie DeMartino. Paulina now works in New York as a senior designer for the fashion accessories label Kate Spade. Paulina Reyes' work has been published and recognized by such organizations and publications as AIGA, *i-D Magazine*, and *Communication Arts*, among others. In 2006 she was selected as one of the Young Guns by the Art Directors Club.

Processor Design

www.processordesign.se

Processor is a design studio based out of Stockholm and Gothenburg, founded by Nina Roeraade, Anna Nilsson, and Helena Engarås. Processor designs and manufactures ecological fabrics with fresh ideas and designs. Its design concept is based on contrasts, evident in its patterns, where dinosaurs cohabitate with excavators, romantic flowers, and scaffolding. One of its trademarks is to use a limited number of colors without abandoning the complexity of a design. Processor was founded in the fall of 2004. All of its members studied at the Textile University College in Borås.

Rachel Kelly

www.interactivewallpaper.co.uk

From Interactive Wallpaper, a small English company, Rachel Kelly has been offering consulting services and designing original wallpaper since 2002, always involving the client in the process. Her paper is made with a background pattern on which decorative stickers are placed, attaining a very personalized result. The positioning of the stickers is chosen on-site, so that they may adapt to the nature of the environment. Rachel's work has received awards from The Homes and Garden Classic Design Awards and has appeared in publications like *Elle Decoration* and *The Observer*.

Reed Danziger

www.reeddanziger.com

Reed Danziger (Berkeley, California, 1966), graduated with a degree in art from the University of California in 1990, and from the San Francisco Art Institute in 1995. In the last ten years, his work has been shown in galleries in New York, Los Angeles, and San Francisco, aside from being included in exhibitions and sample collections at galleries and museums in those cities. His work, intricate and complex, has been defined as "an explosion of particles," and refers to nature's shapes and the purely ornamental art of ancient cultures. Reed works in silk screen just as often as he draws by hand or paints by brush.

Rinzen

www.rinzen.com

Rinzen, an Australian artist collective, is without a doubt one of the few immediately recognizable names to those unfamiliar with the world of graphic design. Created in 2000 as an off-shoot of the famous RMX audiovisual project, Rinzen is comprised of artist and graphic designers Steve and Rilla Alexander (Berlin), Adrian Clifford (Brisbane), Karl Maier (Sydney) and Craig Redman (Sydney). Among their latest works are the design for Paul Pope's first issue of *Batman* and the design for a limited edition bicycle made by the Japanese company Bebike. Their work has been shown at the Louvre.

Sari Syväluoma

www.sari-syvaluoma.com

Artist and textile designer Sari Syväluoma was born in the north of Finland and has lived and worked in Norway since 1994. She graduated from the University of Industrial Arts in Helsinki in 1996. She founded her own company in 1999, though she continues to work freelance. Influenced by Finnish art and architecture, Sari has modernized Norwegian design. Her work integrates different techniques and materials and it shows an interest in technology. Her fabrics are sensuous yet functional, with a style that mixes Scandinavian simplicity with daring colors and rich Indian textures.

Simone Jessup

www.simonejessup.com

Simone Jessup is a fashion illustrator and graphic designer. She lives and works in Venice, California, though she was born in Melbourne, Australia. There she spent the majority of her childhood drawing anything that could be drawn, on any surface she could draw on. Among these surfaces, the walls of each and every room in the house were included. For her drawings, Simone begins with everything that surrounds her: the people, the colors, or the beauty of the cities she is visiting. Her illustrations have been used as a decorative motif by various international fashion labels.

Sonia Chow & Huschang Pourian
www.chowpourian.com

Sonia Chow and Huschang Pourian are ChowPourian, an illustration and graphic design studio from Tokyo, Japan. Their work covers graphic design, fashion, illustration, jewelry, lighting, and furniture design. Sonia is Canadian. Throughout her career, she has received nineteeen international prizes in different categories. Huschang, for his part, is the creator of the Ooito fashion label, also doubling as a freelance designer for companies like Lintas Advertising and Young & Rubicam. After moving to Japan in 2003, he was appointed art director of the lifestyle magazine published by Volkswagen, *View*.

Studio Job
www.studiojob.nl

Comprised of designers Job Smeets and Nynke Tynagel, the Belgian-Dutch duo Studio Job erases the barriers between art and design by creating a universe based on their own personal obsessions and fascinations. From this, their work has often been classified as coming from "a fantastic world in a fairy tale," though oriental art influences are also evident. Among Studio Job's designs are unique pieces, installations, interior designs, and projects destined for public spaces. Among their clients are names like Bisazza and Swarovski.

Telegramme
www.telegramme.co.uk

Telegramme started without any money, designing with old, broken PC's and sharing passions: music, art, and getting mail. For that reason, Cristopher and Robert, from Bristol and Cornwall respectively, worked and communicated through the postal service. Today, these two illustrators and designers are established in London, where they print and create patterns. They define themselves as computer fans, music obsessive, compulsive tea drinkers, a little bit dyslexic, stamp and letter collectors, and trash-can raiders. Telegramme uses traditional elements and formats and transforms them to their taste.

Tracy Kendall
www.tracykendall.com

Designer Tracy Kendall, based in London, is redefining the concept of colored paper. She started designing wallpaper in 1996 with large-scale cutlery designs, flowers, and feathers—audacious graphic imagery that fit just as well in a domestic interior as a commercial space. Tracy treats the paper like a fabric, manipulating it to create 3D effects. The interiors themselves serve as muses for her work, as she manages to capture elements of a room only to reintroduce them into the design and offer an improved interior style.

Yayoi Kusama
www.yayoi-kusama.jp

At barely ten years old, sculptor, painter, and novelist Yayoi Kusama (Matsumoto, Japan, 1929) started using blocks as the central and practically only element of her watercolors. Almost seventy years later, Yayoi's work continues to be identifiable thanks to these blocks. In 1957, Yayoi moved to the United States and returned to Japan in 1973, where she combined her artistic career with the publication of various novels and the production of a vast collection of open air sculptures. Her work has been called a mix of surrealism, minimalism, art brut, pop art, and abstract expressionism.

INDEX

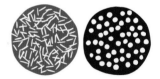